IMAGES
of America

VESTAVIA HILLS

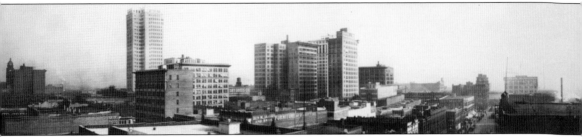

Shown here is the skyline of the "Magic City" in 1916. At this time, Birmingham's economy was on the cusp of its industrial boom. Many of the earliest families to settle on Shades Mountain moved there from Birmingham proper, propelled to find a quieter, more secluded place to raise their families. (Courtesy of Shades Mountain Baptist Church archives.)

ON THE COVER: Shown here are four of the first firefighters who served Vestavia Hills. They are, from left to right, Bill Brenemen, Roy Maddox, Jim Smith, and Bill Towers. The truck shown at far right in the rear was acquired by the city from Anniston. After the city entered a winning bid for the truck, part of an auction that also included old police cars, Bill Towers, Macky Warren, and his father, Mack Warren, drove to Anniston to retrieve it. (Courtesy of Norma Breneman Warren.)

IMAGES
of America

VESTAVIA HILLS

Rebecca Cybulsky Walden

ARCADIA
PUBLISHING

Published by Arcadia Publishing
Charleston, South Carolina

Printed in the United States of America

Library of Congress Control Number: 2014934891

For all general information, please contact Arcadia Publishing:
Telephone 843-853-2070
Fax 843-853-0044
E-mail sales@arcadiapublishing.com
For customer service and orders:
Toll-Free 1-888-313-2665

Visit us on the Internet at www.arcadiapublishing.com

*To Rett, without whose support writing of any
kind would be wishful thinking.*

CONTENTS

ACKNOWLEDGMENTS

My journey began at the Birmingham Public Library Archives. I owe ample thanks to Jim Baggett and Don Veasey. With dozens of pictures in the Vestavia Hills files, and little contextual detail, we analyzed every last photo detail, from attire to architecture, to determine their time. There are few intellectual endeavors as impressive as the mind of a library archivist at his best; I'm honored to have worked with two of the Southeast's finest.

I also wish to thank the many Vestavians who hosted me in their homes and shared some of their most cherished photographic heirlooms, now preserved for others to enjoy through this title.

Topping this list is Norma Warren, whose grandparents Rosa and Leonard Terrell were among the earliest settlers to the area. Norma and her husband, Macky, graciously hosted us in their home over Christmas break in 2013, where Macky kept my children captivated with a steady supply of homemade cookies and the wondrous knickknacks around their house while Norma and I pored over family photographs.

Through additional research, I also reconnected with several people who have shaped my academic, social, and religious education, including Sondra Richardson, my eighth-grade English teacher and present-day historian for Vestavia Hills United Methodist Church (VHUMC); Beth McCord, my junior high unified arts teacher, now a well-known actress in the community; Michael Gross, former principal of Vestavia Hills High School, of "Hold It Up" state championship fame; and Dot Renneker, former Vestavia Belle sponsor and longtime role model to me of what it means to exude Southern charm and class. I also wish to thank Dennis Anderson of Vestavia Hills Baptist Church (VHBC), Linda Anderson, Pat Boone, Merryl Taylor Cooper, Linda Dunn, Becky Gentry, Kim Hancock of Shades Mountain Baptist Church (SMBC), Marietta Juliano, Mark Richardson of Vestavia Hills Elementary East (VHEE), William Mote, Rob Moxley, Karen Odle, Diane Ray, Cindy Chancey Tyus, Lee Wooten, Sara Wuska, and Butch Zaragoza. This book is richer for the time, photos, and memory sharing moments you spent with me.

I would be remiss not to thank my editor at Arcadia Publishing, Liz Gurley, for her insights, assistance, and enthusiasm throughout the project.

My most heartfelt thanks are to my husband, Rett Walden, for the countless hours he spends doing the lion's share of parenting while I pursue ever larger writing projects. If there is anyone in this world who understands why I write and what it does for my soul, it is you. Thank you for helping me live out my dream. I love you.

INTRODUCTION

While the story of George Ward and his "Temple of Vesta" is well known by many Vestavia residents, what transpired in the decades after, specifically in the lives of everyday residents, is lesser known, and speaks to the heart of this book project.

Images of America: *Vestavia Hills* is designed to take readers on a photographic journey of the families who settled on the mountain where this city was eventually built and to offer a glimpse of the city in its early years. It includes the memories of three generations, whose vision and entrepreneurial spirit formed the backbone of Shades Mountain.

The story began, of course, with the vision of one man, former Birmingham mayor George Ward, who purchased acreage in the area in 1923. Two years later, Ward's Temple of Vesta was complete, and he moved into the Roman-influenced structure, designed by William Leslie Welton of St. Louis. That same year, some of the families who would become the earliest pioneers of the city were inching their way closer to the mountain. One such family was that of Walter Hickman Mote and Annie Clay Stubbs Mote. As Ward was purchasing acreage, the Motes were baptizing their children in nearby Edgewood Lake. Descriptions of the parties held at George Ward's Vesta Temple are the stuff of legend. Glamorous and opulent surroundings flanked by meticulously cared-for grounds, with peacocks strutting around for added flair, are the descriptions offered up by the generation that remembers the stories shared by their elders—those lucky enough to garner an invitation to the estate for which the city is named.

Harry and Rachel White were one such couple. Their patronage of the estate continued long after its heyday. Most Sundays, the Whites, along with scores of other settlers to the area, could be found enjoying the residence in its second life; in 1948, under the direction of Charles Byrd and Byrd Real Estate, it became the Vestavia Gardens Restaurant, offering classic Southern fare, immaculately groomed courtyards, gleaming goldfish ponds, and unparalleled views.

In November 1950, the City of Vestavia Hills, named for Ward's Vesta and adding the word "via" (Latin for "roadway"), was incorporated. By the early 1950s, young families began to settle along what was then a new neighborhood block on Eastwood Place, then surrounded by woods. Those residents included Ben and Ruby Jagoe, as well as Bobby and Sue Strozier. Jagoe and Strozier first began developing the area in 1946, when Strozier dammed up Vestavia Lake. By 1952, Strozier, who already owned 40 acres on the Vestavia Lake side of the creek, began working with a Mr. Comer, who owned another 40 acres on the other side. That same year, Strozier sold five acres of his property to Vestavia Hills Methodist Church. The parcel included his own house, which stood for 39 years and two days before the church began construction on its recreational lighthouse. For the rest of the 1950s, Strozier, Comer, and Emmett Cloud collaborated to further develop this area of the city, extending all the way down to where Tanglewood is today. In this decade, nearby Chestnut and Hickory Roads also began to establish themselves.

In the way of modern conveniences, early settlers to the area were ahead of their time. The nearest place to buy groceries was several miles away, at Hill's Supermarket in Homewood. Similarly, the nearest place to buy gas was the Shell station, which still stands today at the corner of Independence Drive and Highway 31, also in Homewood. If one needed health care, the nearest destination was St. Vincent's, which then had a much smaller footprint than the campus of today. At this time, Montgomery Highway was a two-lane road.

The area had one liquor store, where the Wells Fargo Bank stands today. Residents in the know managed to purchase beer from the store owner as well, albeit under the radar and through the back door.

During this decade, W.O. Haynes was named chief of police and residents Ben Jagoe, Bill Towers (who would go on to become the city's fire chief), and others recognized the need for the city to have its own fire department.

With little in the way of city reserves, it was through a chance conversation Jagoe had with Birmingham Fire Department captain Frank Drake that the city received its first fire truck. Shortly after, Vestavia Country Club opened. What is now the club's upper parking lot was originally used as the grounds for the club's horse stables.

As civic interest picked up in the city, so did the interest of Vestavia's citizens to organize places of worship. In 1911, Rev. W.H. Sellers opened the doors of Whites Chapel, the predecessor to Shades Mountain Baptist Church, the first church in the city of Vestavia.

On the other side of Shades Crest Road, a growing number of families were hard at work raising funds to help open a church of their own: Vestavia Hills Methodist Church. After several years of spring barbecues and other fundraisers, the Methodist church began formally on Easter Sunday, April 5, 1953.

In 1959, Charles Byrd opened the Vestavia Hills Shopping Center at 600 Montgomery Highway South. Though the shopping center included Hill's Supermarket, a drugstore, a hardware store, Snow's Cards and Gifts, and even a small Yeilding's Department Store, the real draw proved to be Woolworth's.

During the shopping center's grand opening, a memorable highlight for many was the "Great Dollar Bill Drop," in which a Woolworth's employee emptied baskets of $1 bills from the store's rooftop onto the crowd. Drawings included prizes large and small. Undoubtedly, the most memorable was a pony, awarded to Sue Strozier.

A popular dinner spot for many area families, Woolworth's was known for its $1.25 supper, which back then bought diners a generously sized hamburger, French fries, and a large Coke.

The shopping center enhanced the city's already thriving recreational presence. In 1945, the Shades Mountain Drive-In opened at 1030 Montgomery Highway South, on the same property occupied by Red Lobster today.

Lincoln Continentals routinely filled the parking lot, where teenagers, many of whom had snuck in by riding in the trunks of friends' cars, would pile together with convertible tops down and settle in for an evening of Annette Funicello and Frankie Avalon classics like *Beach Blanket Bingo*, all at a cost of 50¢ per person.

In September 1948, Joe and Juliette Zarzaur opened up a private supper club on Highway 31 called Joe's Ranch House. In 1965, the restaurant suffered from a fire and was rebuilt at the same location. In 1976, the Zarzaurs moved Joe's to 1105 Mayland Drive, where it remained in operation until 2006.

In 1958, when Joe's celebrated its 10th anniversary, Charles Byrd elected to sell the former Ward home and Vestavia Gardens Restaurant to Vestavia Hills Baptist Church, which had been meeting in the old house since the year before. While much of the property was unsalvageable, visitors who stand in the lobby of Vestavia Hills Baptist Church today will find themselves standing on the very same floors traversed by Ward in the estate's heyday.

Under Byrd's leadership, the city experienced explosive residential growth in the 1950s. His commercial efforts spurred others, including Jesse Todd, who opened Todd Mall across the street not long afterward.

In its first 64 years, Vestavia Hills has evolved from a place unknown, a complete wilderness, into a coveted community. Despite its imperfections, the Vestavia Hills of today remains a place where the values of unity, family, and prosperity undoubtedly reign. These values are not accidental; they were forged in the history that has defined this city since its inception. No doubt these values will shape the city in its next 64 years.

For now, it's fitting to celebrate the city's origin, and its evolution.

One

THE EARLY YEARS
PRIOR TO 1950

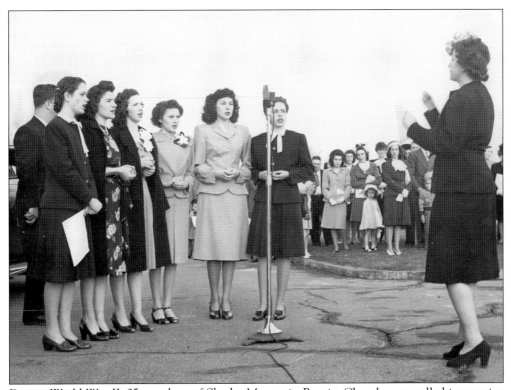

During World War II, 35 members of Shades Mountain Baptist Church were called into active duty. The congregation supported these families in a number of ways, including providing each man sent to war with a copy of the New Testament. Boxes of food were also sent, as well as notes of encouragement and care packages. Of those who served, four did not return home: Carl Siefert, Nunnie LeBerte, Ralph Richardson, and Steven Remick. (Courtesy of SMBC archives.)

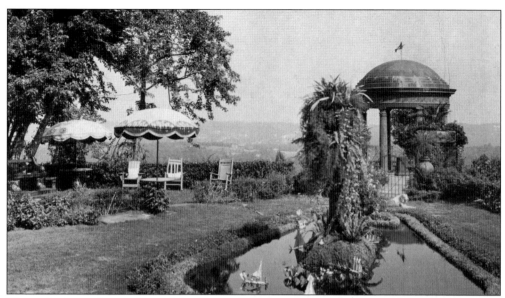

Shown here are the gardens of the George Ward estate. The grounds were known for their opulent landscaping, flamboyant peacocks, and breathtaking views. Near the gated entrance to his estate, Ward kept a light, set either to red or green, indicating when the gardens were open for public viewing. As the estate was prepared each planting season for fresh bulbs and flowers, Ward was known to extend personal invitations to both Mary Maddox and Katherine Terrell to visit and take whatever fresh plantings they liked for their own home garden use. According to Norma Breneman Warren, the arrangement gave the first Shades Mountain Garden Club its origin. (Courtesy of George Ritchey.)

In 1949, Shades Mountain Baptist Church pastor James Charles "J.C." Miller performed the baptism of John Petticord (pictured), who was 100 years old at the time. In 1954, Petticord passed away at the age of 104. (Courtesy of SMBC archives.)

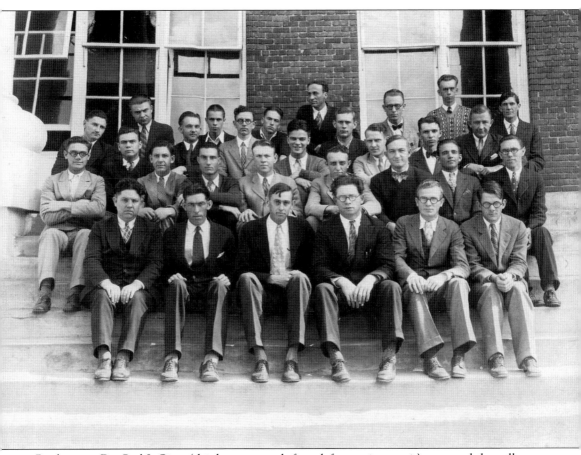

By the time Dr. Carl J. Giers (third row, seventh from left, wearing a suit) answered the call to serve as pastor on September 27, 1961, he already had nearly four decades of formal education and professional experience under his belt. Giers held degrees from Carson-Newman College and the Southern Baptist Seminary, along with two honorary degrees, one a doctor of divinity degree from Carson-Newman and the other a doctor of civil law degree from Atlanta Law School. (Courtesy of SMBC archives.)

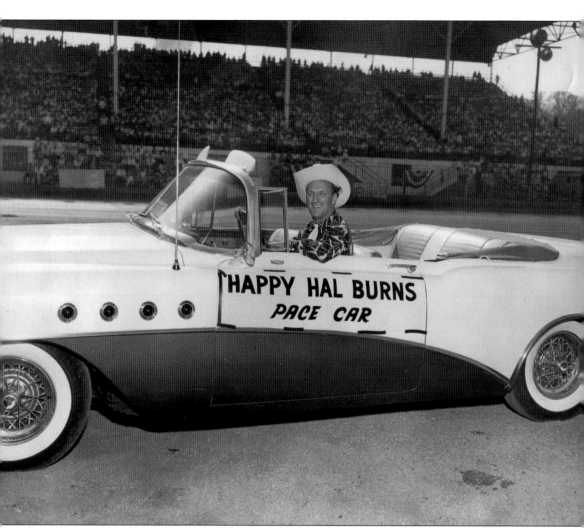

Shown here is local legend and radio icon "Happy Hal" Burns sitting in the driver's seat of his beloved Cadillac. He earned his nickname while on *Garrett's Variety Show* in Memphis. Part of a regular cast of radio personalities, he earned a reputation for always delivering a happy story or joke as part of his routine. After serving in World War II, Burns relocated to Birmingham. (Courtesy of Connie Burns.)

Sybil Temple is seen here in 1930. George Ward maintained the estate until his death in 1949. (Courtesy of George Ritchey.)

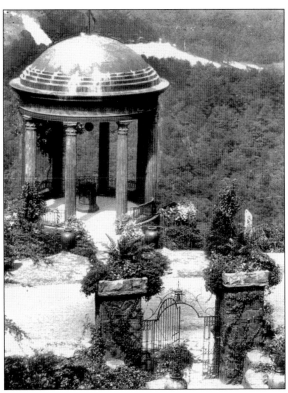

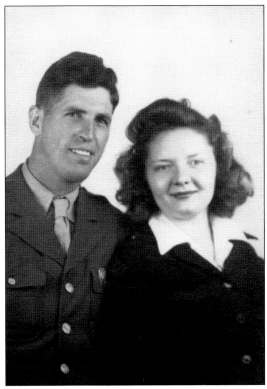

Raymond and Ann Hundley were among many members of Shades Mountain Baptist Church involved with the US armed forces. Through the church's military support ministry, these families received notes of encouragement and care packages from the home front during their deployment. (Courtesy of SMBC archives.)

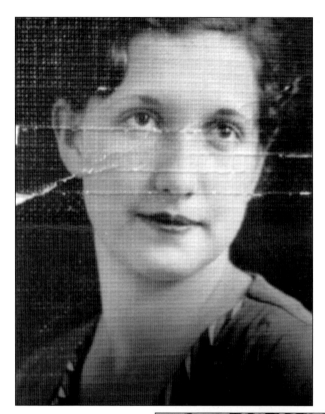

Dorothy Evelyn Harris Vaughan served as the first paid secretary of Shades Mountain Baptist Church. An avid reader, Vaughan also helped establish the first library of the church. (Courtesy of Tana Lee Thigpen.)

From left to right are Fanna K. Bee, then serving as the librarian of Howard College (now Samford University), Frances Fleming, and Dot Harris. They are standing in what was the first library in the history of Shades Mountain Baptist Church. (Courtesy of Tana Lee Thigpen.)

Montgomery School students are pictured here in the early 1900s. These students were among the first who Rev. William "Uncle Billy" Sellers worked with as he attempted to create a community of faith out of the growing population in the Shady Rock area. Sellers originally joined the Missionary Baptist Church at Mars Hill in 1894. By 1902, he was licensed to preach. (Courtesy of SMBC archives.)

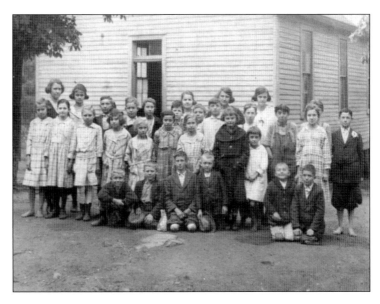

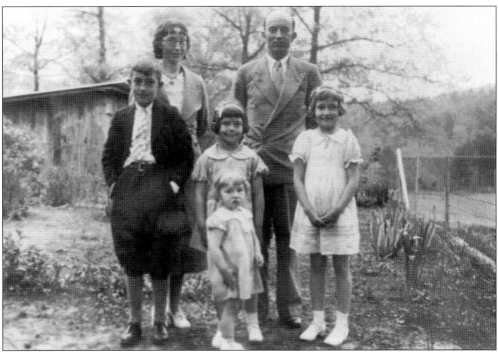

The Tollett family is seen here in 1924. They are, from left to right, (first row) Betty; (second row) Earl Jr., Lexie Mae, and Florine; (third row) Wilhemina and Earl. Wilhemina went on to become the historian of Shades Mountain Baptist Church. After she passed away, Earl Tollett married Eloise Falkner, who served as Girl Scout leader for the troop sponsored by Shades Mountain Baptist. A favorite project of the group took place each Christmas. At that time, Falkner, using monetary donations from the Girl Scouts, made hand-sewn clothing for the children selected by the troop as part of their Christmas giving. (Courtesy of SMBC archives.)

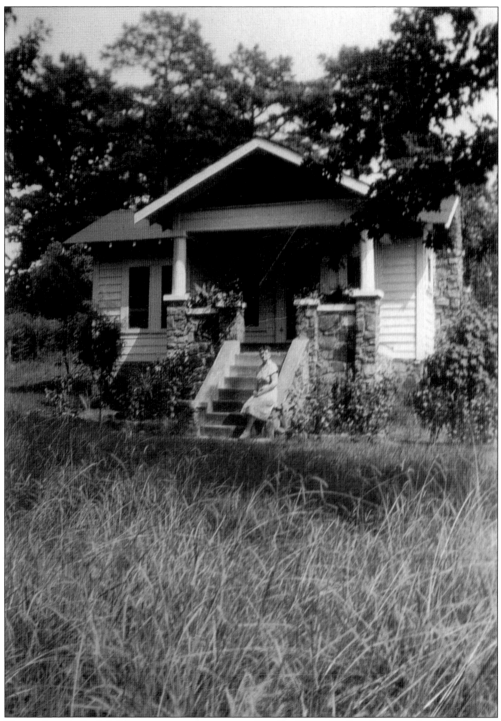

Shown here is the Maddox property as it appeared in the 1920s. Today, this same lot holds Mister Car Wash. (Courtesy of the Bill Maddox family and Vestavia Hills City Hall.)

Charles Hundley (right) is pictured with a traveling circuit preacher who was one of many visitors to Shades Mountain Baptist Church. The Hundley family has an enduring legacy within the history of the church. (Courtesy of SMBC archives.)

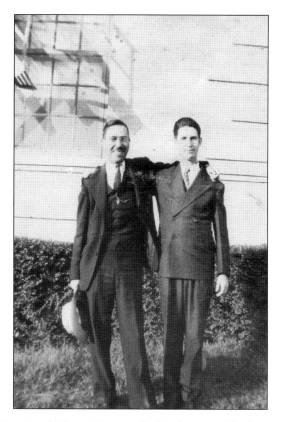

Louis and Minnie Pizitz made their home on Shades Mountain several years after Louis emigrated to the United States from his native Poland in 1889. Though penniless, Louis slowly established himself as a street vendor and, 10 years later, the entrepreneur behind Pizitz Department Stores, which went on to become the largest home-owned department store in Alabama. In the 1960s, Louis and Minnie's son, Hortense, began giving portions of property the Pizitz family owned in the Shades Park area to the City of Vestavia Hills. These portions were eventually selected as sites for Vestavia Hills Junior High School (now Pizitz Middle School) and Vestavia Hills High School. According to historical documents from the middle school, Vestavia Hills Junior High School students attended Berry High School until 1970, when Vestavia Hills High School was built. Also in 1970, when Vestavia Hills withdrew from the Jefferson County School System to establish its own system, the junior high was renamed as per the original wishes of the Pizitz family to Pizitz Middle School. The only trace of the school's original ties to Berry are reflected in the mascot, the pirate. It was adopted in keeping with the theme of Berry's mascot, the Buccaneer. (Courtesy of the Pizitz family and Pizitz Middle School.)

Henry Jacobs was the son of George Jacobs, an early pioneer of the Shades Mountain area. Henry married the former Sansanah "Sanny" Munkus. Born on May 18, 1857, he was just one day shy of his 60th birthday when he passed on May 17, 1916. (Courtesy of SMBC archives.)

Rev. John Thomas "J.T." Screws is shown here with his wife, Millie, on their 50th wedding anniversary. Reverend Screws served as pastor of Shades Mountain Baptist Church from 1922 to 1926. Born on April 29, 1866, Screws was 56 years old when he became pastor. He remained in that post for four and a half years. He passed away on November 23, 1952. (Courtesy of SMBC archives.)

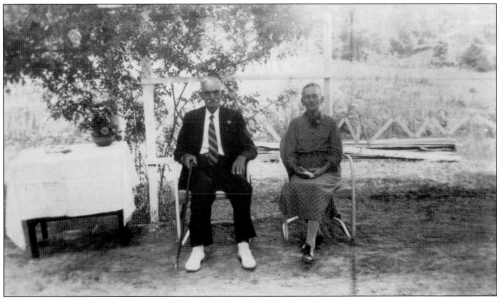

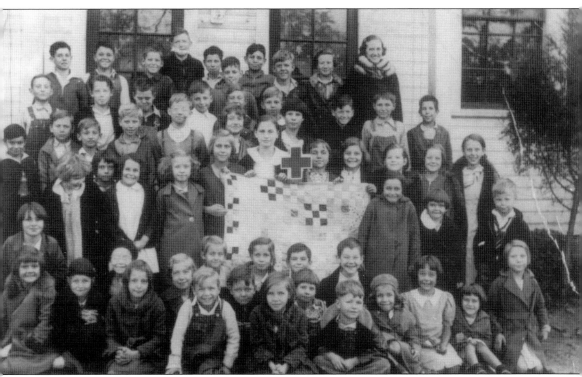

The quilt shown here was a project of the Women's Missionary Union (WMU) of Shades Mountain Baptist Church. The group often met in homes, allowing its members to quilt and make other items, including clothing, to help the needy. In addition to helping fund a new piano for the church, proceeds from WMU-sponsored events also helped cover the church's insurance premiums and extend support to orphans' homes. (Courtesy of SMBC archives.)

Shown here is George W. Jacobs, originally from Germany. Born on July 19, 1832, Jacobs moved to the United States as a young man, where he became an early pioneer of the Shades Mountain area. He passed away on Christmas Day in 1893. (Courtesy of SMBC archives.)

Rev. J.C. Miller served as pastor of Shades Mountain Baptist Church from June 1930 to June 1944, and again from October 1946 to June 1951. His wife, Elizabeth, was affectionately known as "Big Mama." Under Miller's leadership, the church flourished in membership and giving in the post-Depression era. When sister church Patton Chapel Methodist burned in 1939, Shades Mountain Baptist designated a portion of its collection—typically $5 every third Sunday—to help that church rebuild. (Courtesy of SMBC archives.)

This is a portrait of Rev. J.T. Screws of Shades Mountain Baptist Church. On September 2, 1923, he performed the earliest recorded baptisms in the history of the church. These baptisms were performed in the private swimming pool of the summer home of Louis Pizitz. Those baptized included Robert Wesley Dean, Walter Conrad Dean, Ralph E. Kennedy, Earl Wesley Kennedy, Marjorie Chambliss, Ollie Chambliss, Margaret Lee Kennedy, Louis Kopp, and Pauline Kopp. (Courtesy of SMBC archives.)

Ricky Hamilton is pictured here with his parents, Wilson and Dee. Ricky was the first individual in the history of Shades Mountain Baptist Church to achieve the rank of ambassador extraordinary in the Royal Ambassadors program. (Courtesy of SMBC archives.)

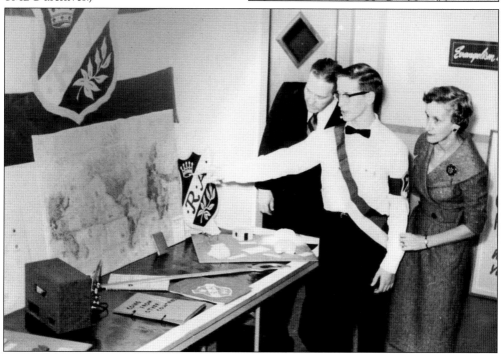

Shown here is Sam Strozier, son of Elizabeth Mote Strozier and John Aubrey Strozier. On one memorable Saturday, Sam, along with a few other men from the congregation of Shades Mountain Baptist Church, set out to dig a basement under the church building. By nightfall, the exhausted men decided that the use of dynamite was in order to most efficiently rid the work area of rock. Instead of making headway on the basement, they instead created an urgent need for post-dynamite repairs. On a Sunday in June 1938, Sam and Clara Mote were married by J.C. Miller. Their decision to marry at that time was so the whole family could attend. (Courtesy of SMBC archives.)

Sansanah Munkus Jacobs, pictured here, was born on September 27, 1870. She was the wife of Henry Jacobs, whose family pioneered the Shades Mountain area at the turn of the 20th century. (Courtesy of SMBC archives.)

Shown here are Tom Carter and Jane McMahon at a ceremony honoring Girls in Action ("GAs" for short) at Shades Mountain Baptist Church. During such ceremonies, it was customary for the teenage girls being honored to be accompanied by younger attendants, often as young as age four or five. (Courtesy of Frankie Carter.)

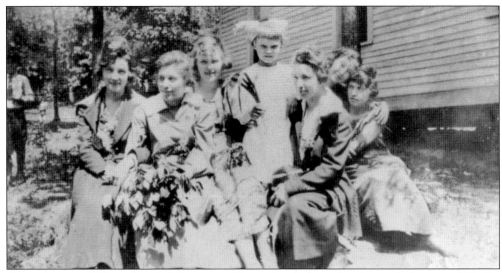

Shown here are lifelong friends from some of the earliest known families in the history of Shades Mountain Baptist Church, including, from left to right, Zilphia Brown Jacobs, Fannie St. John, Mary Massey Skaggs, Hazel Massey Kennedy, Annie J. Walker, Eirelle Follett, and Bertha Elliott. Well into the twilight years of their lives, many of these women continued to meet regularly for social and faith-based events. (Courtesy of SMBC archives.)

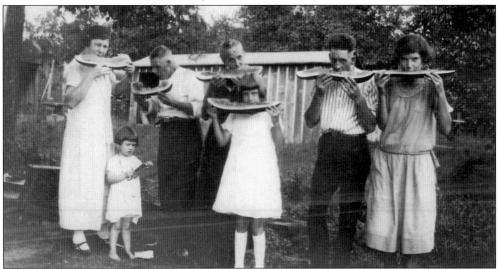

The Mote family was among the earliest residents of Shades Mountain. The adults pictured here are, from left to right, Brewer DeLoach, Bill and Susie Mote, and Henry and Nellie Mote, along with two of the Mote children around 1924. Just one year prior, Mote had relocated his family to Shades Mountain from the Highland Avenue/Forest Park area. He established the family homestead at Old Orchard Road, where he purchased 80 acres. The home still stands today. It was built from lumber and stone sourced directly from Mote's lumber mill and finishing mill. True to its name, Old Orchard Road did include an orchard. What was an overgrown area quickly began to thrive under the care of the Mote family, who operated a productive farm complete with cows and chickens. By the late 1920s, Mote had moved his parents to the area, where they joined his father's three brothers and sister who had already settled nearby and built houses of their own. (Courtesy of William Mote.)

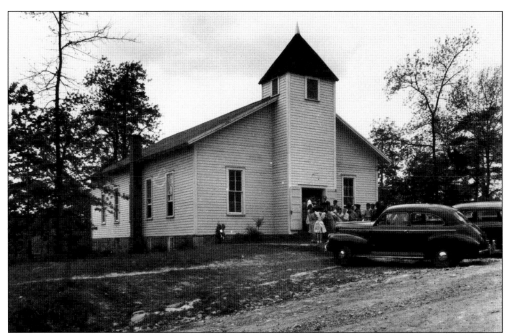

When Miller Chapel was torn down in 2008 to make way for a new building on the campus of Shades Mountain Baptist Church, the news was bittersweet for many who had spent their childhoods worshipping there. Prior to the chapel's deconstruction, Tana Lee (Vaughan) Thigpen took it upon herself to organize a reunion. Using her own records and church records (her mother, Dorothy Vaughan, was the church's first paid secretary), Thigpen personally called 300 individuals, inviting them to the affair. On the day of the reunion, nearly 200 people showed up to honor the memories made at Miller Chapel. (Courtesy of SMBC archives.)

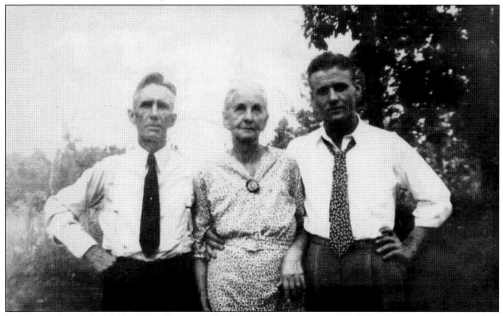

Taken in the early 1940s, this photograph shows three generations of the Mote family. From left to right are Matt Brooks, Ada Mote, and Ted Brooks. (Courtesy of William Mote)

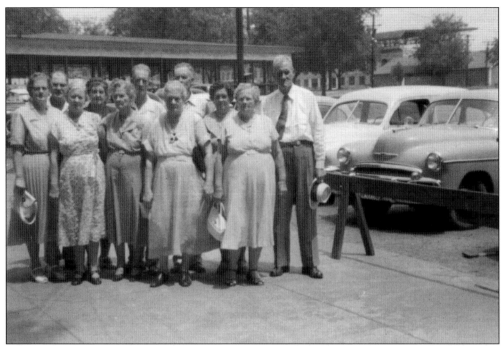

The Mote family is pictured in the 1950s. From left to right, the women are Margie, Ada, Pearl, Jane, Maggie, Emma, and Della. The men are Arvie, Henry, Walter, and Dee. (Courtesy of William Mote.)

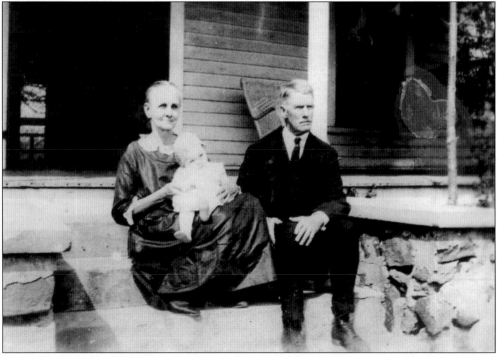

In 1926, baby Mildred Lee Mote lost her mother in childbirth. She was raised by her maternal grandparents, Susie Anna Mote and William Asbury Mote, seen here. (Courtesy of William Mote.)

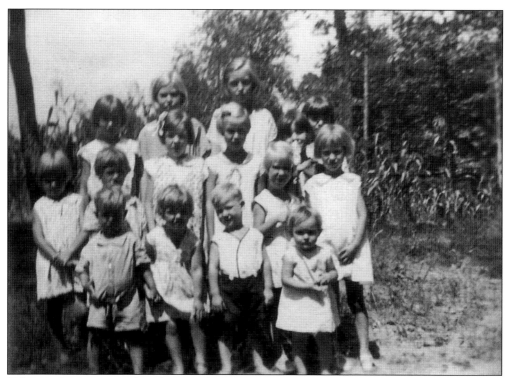

Taken in August 1932, this photograph shows the children of Margie and John Thomas Mote. Among those pictured are Hickman Mote, Mary Mote, Kenneth Mote, Betty Mote, Frankie Thomas Mote, Tommy Mote, Mildred Mote, Belvia Mote, Talley Mote, Opal Hill, Della Mae Hall, and Dorothy Martin. Frankie Thomas Mote went on to marry Gerald Carter. Many remember her fondly as the Shades Mountain Baptist Church hostess, preparing delicious home-cooked meals that were served family-style every Wednesday night. Frankie and Gerald spent many a Saturday waterside, where they were part of a group known as the "River Rats," along with Frances and Wessel Fleming, Bob Vaughan, and Joe Mote. Together, the Rats pulled many area children up and down the river for days full of waterskiing. (Courtesy of William Mote.)

In the late 1950s, Frankie Carter's was a popular gathering spot for special events. In 1957, the Mote family hosted their reunion there, with attendees including, from left to right, (first row) Della, Maggie, Jane, Ada, Margie, and Arvie; (second row) Walter, Emma, Henry, and Pearl. (Courtesy of William Mote.)

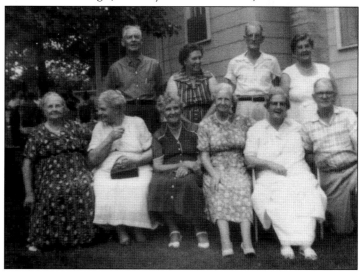

After the Pizitz family vacated their beloved home, Happydale, it was acquired by Sammy Fiorella, at which point the residence earned a sordid reputation as a spot for illegal gambling. According to Butch Zaragoza, Sammy was always one step ahead of local law enforcement, and had always been able to hide his gambling equipment prior to every police raid. Curiously, the Pizitz house was built with secret hiding spots within the walls and all over the house, giving Fiorella a convenient way to quickly remove any evidence of gambling. The passages were not discovered until many years later, when Vestavia Park Apartments acquired the property and began remodeling. By that time, Fiorella had relocated to Shelby County, where he owned and operated another gambling facility, known as The Chicken Ranch. (Courtesy of David Miles and Pizitz Middle School.)

Friends since their grade school days at Shades Cahaba School, the Daniels sisters, Lucille (left) and Velma (right), and Katherine Terrell (center) remained lifelong friends. In 1932, Lucille Daniels married Mack Warren. That same year, Katherine Terrell found work at the Birmingham Paper Company, where she met and married Bill Breneman. Years later, Mack and Lucille's son Macky and Bill and Katherine's daughter Norma would marry as well. (Courtesy of Norma Breneman Warren.)

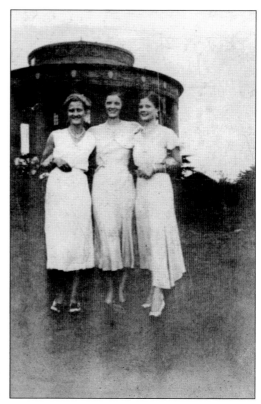

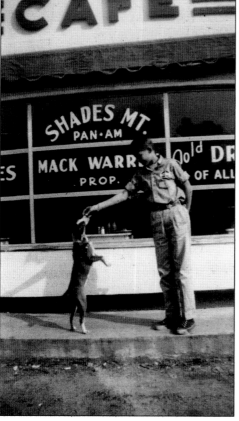

In 1943, the Warren family took over the property at 529 Montgomery Highway. Under their ownership, the property became Shades Mountain Pan Am. The service station included four gas pumps, a lane for tire repair, a lane for oil changes, and a café serving meals prepared by Lucille Warren. Patrons kept coming back for Lucille's homemade barbecue, hot southern style breakfasts, and grill items. By the time of the city's official establishment in 1950, Lucille's regulars included workers of Charlie Byrd, who had started building houses south of the mountain. Lucille's son, Macky, is shown here in front of the café with the family dog, Princess, who is drinking a Coca-Cola. Inspiration for the photograph came from the Coca-Cola delivery man, who'd gotten to know Macky and Princess on his inventory runs. (Courtesy of Norma Breneman Warren.)

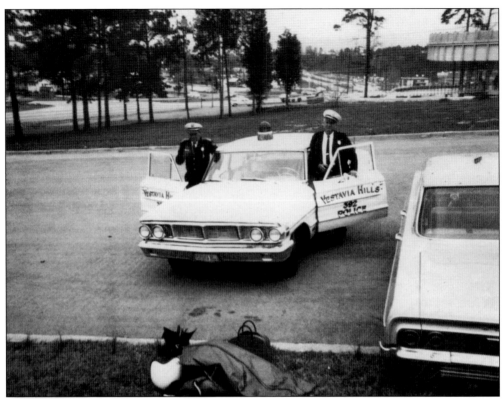

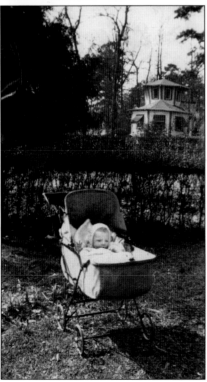

While Joe Dean served as the first Vestavia Hills policeman, the city's first police chief was W.O. Haynes, shown here on the right with Bill Breneman. The force was established in 1950. Not long afterward, Haynes deputized Breneman to help increase the manpower in the newly formed unit. Haynes was known to park in the neighborhood around what is now Granbury Road and Georgia Avenue, then known as Rural Route 2, and venture down into the woods searching for moonshiners. Moonshine activity was so prevalent in the area that, for decades following, homeowners frequently discovered old moonshine jars in their yards. (Courtesy of Norma Breneman Warren.)

Norma Breneman is shown here as an infant on the Breneman property. In the background is a portion of what was known as Kelly's Tourist Court. Kelly's was one of several tourist courts in the Shades Mountain area, including Bob's Tourist Court in Homewood and Owl's Tourist Court near what is now Brookwood Hospital. Norma remembers often wandering up the unpaved lane to Kelly's to play with the children of families who were staying in the tourist court. (Courtesy of Norma Breneman Warren.)

This stone house belonged to Rosa and Leonard Terrell. When the area officially became the City of Vestavia Hills in late 1950, Charles Byrd approached the Terrells intent on buying their lot, as he was many other lots in the area, for commercial development. Though he offered them $20,000 for the property, they would not budge. They eventually sold the lot to Macky Warren's parents, who were looking for a permanent place to live after their rental home, which belonged to Roy Maddox, was set for demolition in 1953 to make room for a new four-lane highway. (Courtesy of Norma Breneman Warren.)

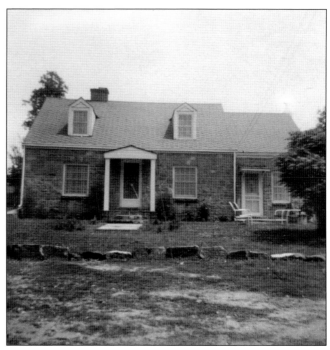

Bill Breneman stands at the side of his in-laws' home, Leonard and Rosa Terrell, the same lot that now houses Iberia Bank. By the time he was grown, Bill lived next door, and at one point owned as much as five acres in the area. The land behind him held a vegetable garden, with a chicken coop on the left. To Norma's delight, when her father tired of keeping chickens, the coop was turned over to her, at which point she promptly made it her own playhouse. It also meant the end of Norma having to hear her father ask her to go get a chicken and wring its neck, saying he would show her how it's done. "No thank you," she'd always reply. "I'll see it when it's put on a plate." In 1950, Breneman sold the home and lot to Charles Byrd for $8,000, relocating the family just down the street to Oaklawn. (Courtesy of Norma Breneman Warren.)

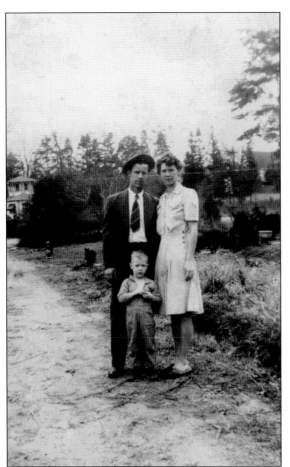

Leonard and Rosa Terrell and their son Marvin posed for this photograph just after Leonard had come home from fighting in World War II. They are standing in the front yard of their home. Behind them is Montgomery Highway, and across the highway is Kelly's Tourist Court. (Courtesy of Norma Breneman Warren.)

Shown here is Katherine Breneman, whose grandparents Leonard and Rosa Terrell opened a grocery store in 1927, the first in this area, after Leonard was laid off from his job with the Southern Railroad and the Depression was worsening. After receiving a loan from First National Bank in Homewood, the Terrells worked with C.S. "Champ" Marable to source the materials for their new store, which was built at the front of their home near the road. Standard Oil Company added gasoline and kerosene tanks, and Rosa kept the store stocked with fresh fruits and vegetables, courtesy of the Mote family's orchards and farms. Katherine, along with her daughter Norma, also worked in the family store. (Courtesy of Norma Breneman Warren.)

Carey Jackson is credited with serving as the first volunteer choir director of Shades Mountain Baptist Church. According to obituary records, Jackson served in World War II after graduating from the US Merchant Marine Academy in Kings Point, New York. He went on to earn the rank of commander of the naval reserve. In his career, Jackson worked for US Steel. During his childhood, his family lived on Tyler Road, where they were loyal members of Shades Mountain Baptist Church. Jackson's father is remembered fondly for regularly greeting the children each Sunday morning with a fresh piece of bubble gum from his suit pockets. That generosity carried on with his son, who remained active in the church's affairs during his membership. When he learned that Tana Lee Thigpen was planning a reunion for Miller Chapel using her own money, Jackson quietly provided her with a donation towards the event. The gesture made quite an impression on Thigpen, who recalls that Jackson's religious ties by that time were in fact at another church in the area, Lakeside Baptist. (Courtesy of SMBC archives.)

Willow Robinson, affectionately known as "Mama Willow," is seen here on a piece of residential property that now is the site of Mister Car Wash. The Robinsons were some of the earliest residents to establish a homestead in Vestavia Hills, long before the city even existed. Their grandson Bill Maddox has spent his entire life in Vestavia Hills and still resides in the city today, off of Old Creek Trail. (Courtesy of the Bill Maddox family.)

W.E. Robinson served as the pastor of Shades Mountain Baptist Church from July 1928 to June 1930. (Courtesy of SMBC archives.)

Taken in the winter of 1940, this photograph is from the vantage point of what is now HoneyBaked Ham. At that time, the area belonged to Roy and Mary Maddox, whose son Bill was born on the lot. As seen here, the Magic City received tremendous snowfall that year. Meteorologists recorded as much as 10 inches of snow at the Birmingham airport during a particularly wintry blast that hit the region in late January. (Courtesy of the Bill Maddox family.)

This photograph shows the backyard view of the home of Roy and Mary Maddox, as well as Mary herself. In the 1920s, Roy moved his young family to this area and bought two three-acre parcels in what is now an alley behind HoneyBaked Ham. Maddox built three homes in the area, one of which still stands today. (Courtesy of the Bill Maddox family.)

Roy Maddox is seen here in front of the Maddox home. He played a pivotal role in the city's earliest formative years. Along with Mayor V.L. Adams, Maddox and others worked to incorporate, based in part on an attempt at gentrification by Adams. At the time, a nightclub by the name of Club 31 stood at the intersection of what is now the Shell station and Canyon Road. According to Adams, it was "nothing but a public nuisance." Following the city's incorporation, the property became Shades Mountain Country Club. The club's owners and operators, G.B. Parsons and Frank Tillotson, remained the same, as did the culture of the club, albeit with a better sounding name. Maddox was also instrumental in helping the area receive its first water mains. At the time, Birmingham Water Works had established service up to Shades Crest Road, but not south of it. After involving several others and working with the Alabama Public Service Commission in Montgomery, Maddox's efforts were successful. (Courtesy of the Bill Maddox family.)

School Days
1944 - 45

Shown here is a young Lexie Mae (Tollett) Miller. Lexie Mae went on to marry Bill Miller, with whom she owned and operated Miller Heating & Air Conditioning in Vestavia Hills. (Courtesy of SMBC archives.)

Shown here is Polly Edwards, who worked as a registrar at Howard College (now Samford University). She and her husband, Jim Edwards, had one daughter, Barbara Edwards Sharp, who became a teacher at Rocky Ridge Elementary. Polly was known for bringing many of the international students she met in the course of her day job back to Shades Mountain Baptist Church for fellowship. Many of these students were attending medical school at the University of Alabama at Birmingham. Edwards's efforts helped Shades Mountain Baptist cultivate its English as a Second Language Outreach Program, which provides English-language training free of charge to anyone interested. Since the program's launch, the church has taught people from Turkey, China, Japan, Korea, and Russia. (Courtesy of SMBC archives.)

Mary Maddox is pictured on the Maddox property, along Parkview Place (now Tyson Drive), near Vestavia Hills Elementary East. (Courtesy of the Bill Maddox family.)

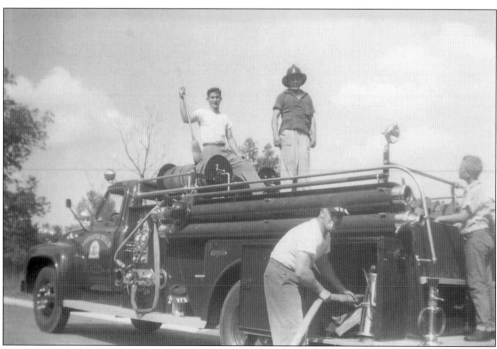

The volunteer firefighters of Vestavia Hills included, from left to right, Bill Maddox, Pete Owens, and Bob Monroe (pumping gas). Monroe went on to become a member of the city council, under the leadership of Mayor V.L. Adams. (Courtesy of the Bill Maddox family.)

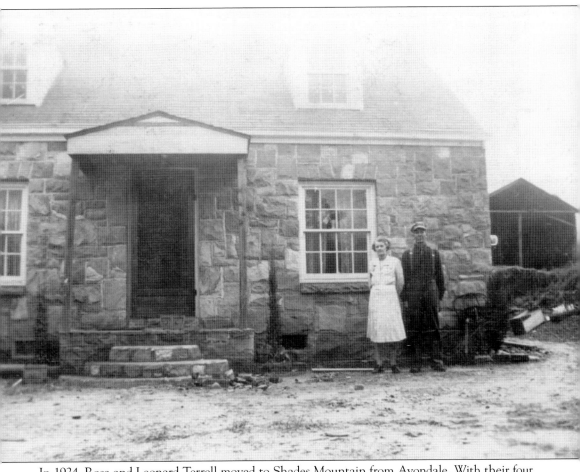

In 1924, Rosa and Leonard Terrell moved to Shades Mountain from Avondale. With their four children, the Terrell family soon opened the area's first grocery store. Rosa came up with the idea after Leonard was laid off from Southern Railroad. The couple is shown here in front of their home during its construction (the finished home can be seen on page 31). It was built by Leonard and his son Wilmer using stone from the quarry behind the Strozier property. After the Terrells sold the property to the Warren family, the second floor of the residence provided lodging for Macky and Norma right after they were married. The couple remained there until Macky, an expert in aircraft engineering mechanics, was drafted by the Navy. (Courtesy of Norma Breneman Warren.)

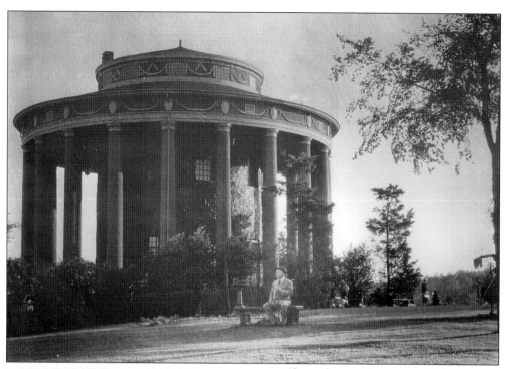

Shown here is George Ward, the former mayor of Birmingham and the visionary behind the Vestavia Temple, where he lived for more than 20 years. This photograph, taken in the 1930s, captures Ward during one of his favorite pastimes: enjoying the elaborate gardens and grounds of the estate. (Courtesy of Alvin W. Hudson.)

Shown here is Joe Mote. As a young Vestavia Hills built up around him, Joe, along with his brother-in-law Gerald and sister Frankie Mote Carter, moved to Thorsby, craving more of a country atmosphere and way of life. In his older years, Gerald Carter is remembered for buying a motorcycle, which he rode with gusto well into his 80s, right up until two weeks before his passing. (Courtesy of SMBC archives.)

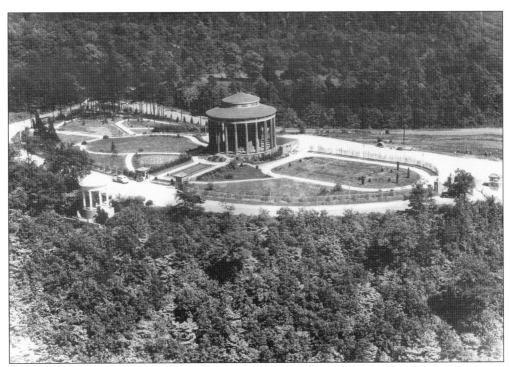

The Vestavia Temple is seen here on April 22, 1949. After George Ward's death, real estate developer Charles Byrd took care to keep the property in decent shape. (Courtesy of Alvin W. Hudson.)

Mary Mote (Herren), shown here, was playing the church piano and organ on a regular basis at the tender age of nine. In 1950, the church organist earned a salary of $25 each month. Herren was one of 10 children belonging to Walter Hickman Mote and Annie Stubbs Mote, who joined Shades Mountain Baptist Church by letter in July 1926. Her siblings were Bernie Mote Walker, Cordell "Jack" Mote, Elizabeth Mote Strozier, Walter Mote, Clara Mote Strozier, Verna Mae Mote Konig, William Mote, Joe Douglas Mote, and Betty Mote Bowen. In July 1963, Walter Hickman Mote, already a deacon at the time he joined the church, was voted into the position of life deacon. He served as Sunday school superintendent and eventually became a trustee. (Courtesy of SMBC archives.)

A large part of church culture at Shades Mountain Baptist Church, particularly in the 1950s, involved the fellowship activities of the Women's Missionary Union and the Brotherhood Youth Organization. One such event included the annual Young Women's Auxiliary (YWA) Sweetheart Banquet. Here, Mary Mote is shown as the YWA Sweetheart Banquet queen. That same year, Bill Miller was crowned YWA Sweetheart Banquet king. At the time, Lexie Mae (Tollett) Miller served as the YWA leader. (Courtesy of SMBC archives.)

This coronation ceremony photograph shows, from left to right, Janet Chambliss, the daughter of pastor Hugh Chambliss; Mike Hamilton; Lou Falkner; and one of the Carter children. (Courtesy of SMBC archives.)

This photograph shows Eddie Cranford during his 1952–1953 school year at Shades Cahaba School. His was the first baptism to take place in Miller Chapel. (Courtesy of SMBC archives.)

SCHOOL DAYS 1952 '53
Shades-Cahaba

The Montgomery Schoolhouse was where Rev. William "Uncle Billy" Sellers first met to provide religious education to the children on the mountain. In 1907, Sellers's request to use the new one-room schoolhouse for this purpose on Sundays was denied by trustees. Once students began to complain, the trustees reversed their decision. The school then served double duty as a place of Sunday school education for the next two decades. (Courtesy of SMBC archives.)

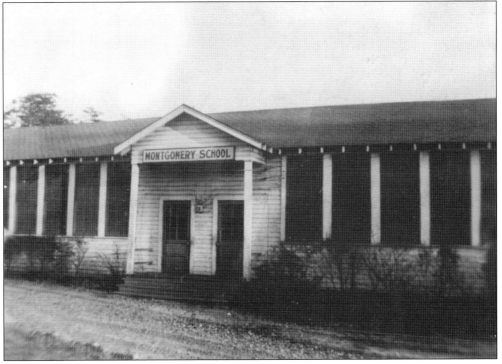

MONTGOMERY SCHOOL

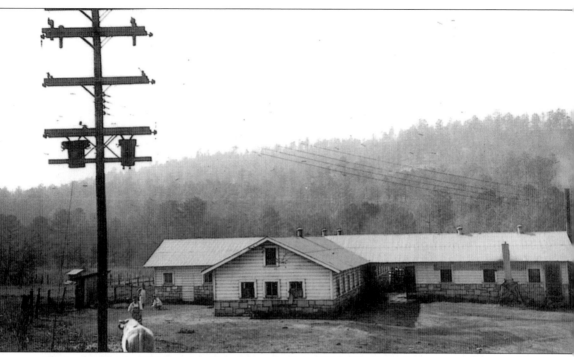

Shown here is the Old Bearden Dairy Farm, built in 1926. The dairy farm, originally owned by Joe Bearden, has since evolved into several different types of businesses, all the while preserving much of the barn's original structure. After many years as Jackie O'Neal School of Dance, the facility went on to house the Artists Incorporated Gallery. Alberta Bearden, the youngest of Joe's 12 children, went on to marry Leon Wooten, with whom she opened Rocky Ridge Grocery and Shell, in 1947. Today, that building stands in front of Wooten Automotive as the former location of Moe's Original Barbecue and Blues Revue. (Courtesy of Robin Morgan and Lynn Buckner.)

In the late 1940s and early 1950s, the Shades Mountain Drive-In was a hugely popular draw for youngsters in the area. It stood where the Red Lobster now stands, in the heart of the city on Highway 31. The photograph below, taken in 1949, shows the entrance. (Above, courtesy of Alvin W. Hudson; below, courtesy of Pat Boone.)

In 1947, Leon Wooten completed construction on the first phase of his Rocky Ridge Grocery, after purchasing the lot from Bert and Ester Oglesby. Shown here is his wife, Alberta Bearden Wooten, working in the grocery. During the grocery's opening sale the Wootens featured many deals and specials, including a dairy case sale advertising two pints of ice cream for 35¢. (Courtesy of Lee Wooten.)

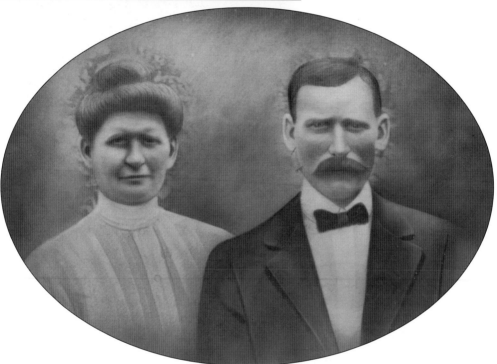

Billy Sellers and his wife, Martha, are pictured here. Billy is credited with creating Whites Chapel Baptist Church, thanks to Sellers's vision that children of families who had settled in the area needed a place to attend Sunday school and church. The church was officially constituted in 1911, shortly after it received acceptance into the Mineral Springs Baptist Association. In that same year, Sellers became reverend of the chapel. By 1917, Reverend Sellers was earning an annual pastor's salary of $25. In 1926, Whites Chapel Baptist Church, originally named after a Sunday school teacher, changed its name to Shades Mountain Baptist Church. By 1927, the church shifted its membership from the Mineral Springs Baptist Association to the Birmingham Baptist Association. (Courtesy of SMBC archives.)

A circuit preacher, Rev. T.C. Walden served as pastor of Shades Mountain Baptist Church from 1918 to 1919. (Courtesy of SMBC archives.)

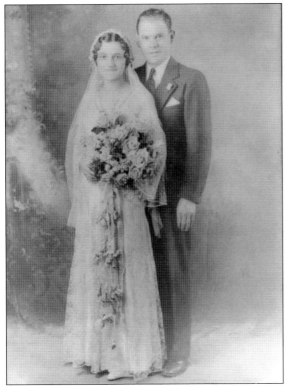

Elizabeth Miller's wedding to Jay D. Tolleson was the first wedding to take place in Miller Chapel, which opened in 1926 after two years of labor and construction by men from the congregation. (Courtesy of SMBC archives.)

Guest singer Williard Evans and evangelist Dewey Adams were among many visitor highlights for members of Shades Mountain Baptist Church during the 1940s. (Courtesy of SMBC archives.)

Mr. and Mrs. J.M. Boutwell can be seen here. She served as the secretary of Shades Mountain Baptist Church from 1907 to 1926. Unfortunately, the Boutwell home burned down in a fire, along with the church minutes. (Courtesy of SMBC archives.)

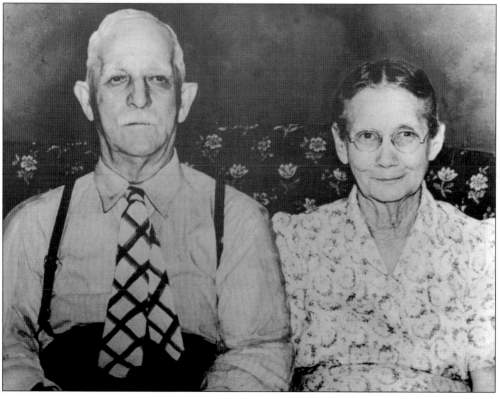

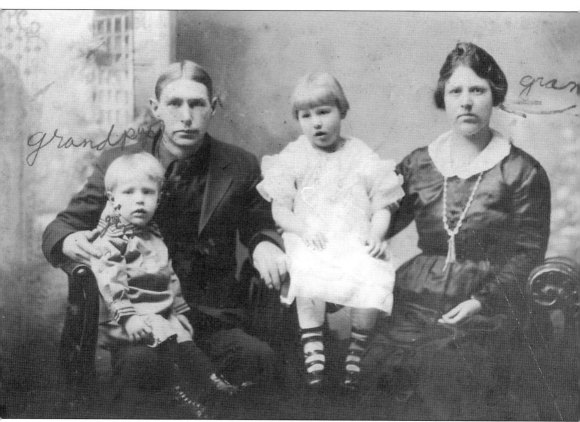

Some of the earliest members of Whites Chapel included the Goodwin family. Jim and Cora Goodwin are shown here with their children Buck and Martha on June 5, 1911. Cora served as the first president of the Women's Missionary Union of Shades Mountain Baptist Church, which was established on June 8, 1926. The group welcomed a distinguished guest at this first gathering: Mrs. Hugh McDonald, president of District 1 in Birmingham. Others present at the meeting included Mrs. I.G. Horton and Mrs. J.E. Davis. As recorded by Cassie Sellers in the July 20, 1926, meeting minutes, the SMBC chapter of the WMU met in the home of Mrs. Helen Weagers. During the meeting, members were called to order with what is described as the "watch word," or phrase, which was, "Go ye into all the world. Ye shall be my witness." After Cora led the group in prayer and several chapters were read aloud, a member presented a motion, which was moved and then seconded, to piece together a quilt. All members present during that meeting agreed to work on the quilt, which is seen on page 19. (Courtesy of SMBC archives.)

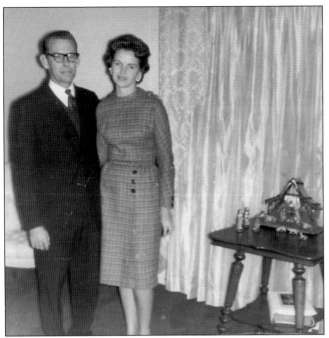

Mary Mote, a talented pianist, went on to provide regular musical accompaniment at Shades Mountain Baptist services in the early 1950s. (Courtesy of SMBC archives.)

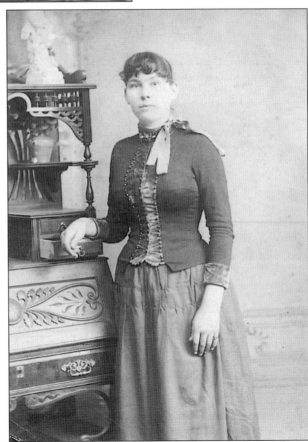

Shown here is a young Millie Samantha (Doss) Screws, the wife of Rev. J.T. Screws. Millie was born on October 24, 1873, and the two married on June 2, 1892. She passed away on December 1, 1964. (Courtesy of SMBC archives.)

Two

FORMING THE CITY
1950–1960

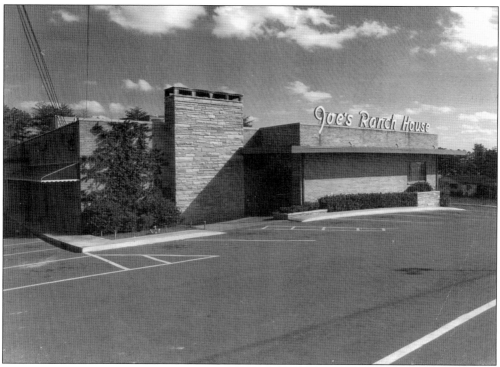

The original Joe's Ranch House was located near the former Pizza Hut. It sat more toward the middle of the lot, between Pizza Hut and Ruby Tuesday. This was the "society" club on the mountain; the food, mostly steaks and seafood, was great, but the biggest draw was that one could "BYOB" because it was a private club. It was also open on Sunday afternoon and evening, which was unheard of then. (Courtesy of Alvin W. Hudson.)

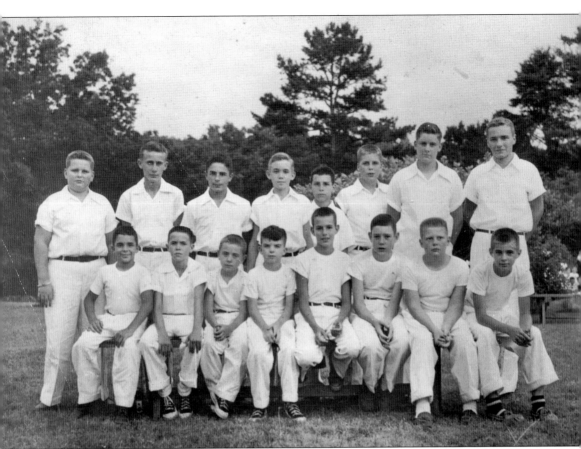

During the summer of 1954, several Vestavia boys joined other Birmingham area youth attending Lookout Mountain Camp for Boys in Mentone, Alabama. Pictured from left to right are (first row) Robin Moxley, Charlie Stewart, Robert Carraway, Jimmy Westbrook, Frank Young, Haran Lowe, Bob Wright, and Danny Gross; (second row) Champ Lyons, Richard Stewart, Dicky Moxley, Tommy Fox, Jack McKay, Lanier Chew, aide Joe Lyon, and camp counselor George Watson Jr. (Courtesy of Rob Moxley.)

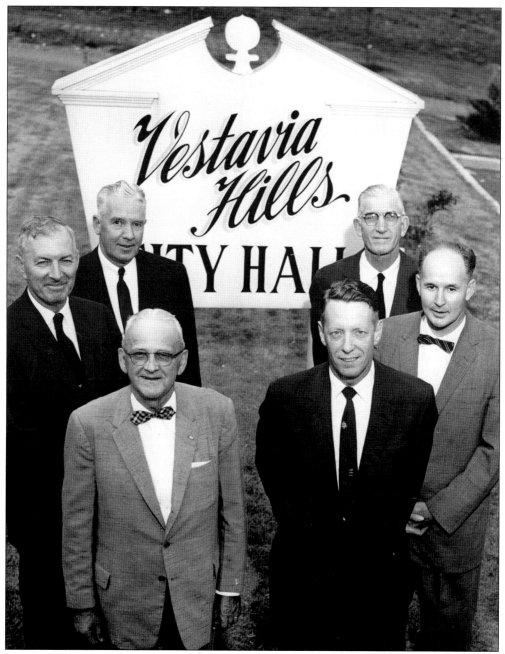

Shown here are members of the first city council of Vestavia Hills. The election took place on Dec. 19, 1950, with Verner L. Adams (front left, with bowtie) serving as mayor. City councilmen, pictured from left to right, were A. Murray Cahill, Joseph H. King, Henry S. McReynolds, R.M. Maddox, and H.J. Tillia. (Courtesy of Leigh Brooks.)

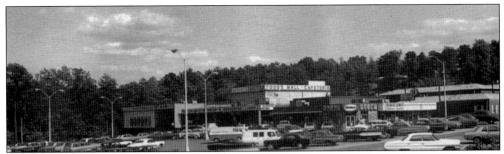

Todd Mall, named for owner Jesse Todd, stood where the Walgreen's stands today. It opened in 1960 with Mrs. Todd's Cafeteria as its anchor store. By the mid-1960s, Todd Mall stood adjacent to the new mall in town. Across the street, the city welcomed another mall, which included a Parisian and a Sears, in a spot formerly used as a trampoline court. (Courtesy of SMBC archives.)

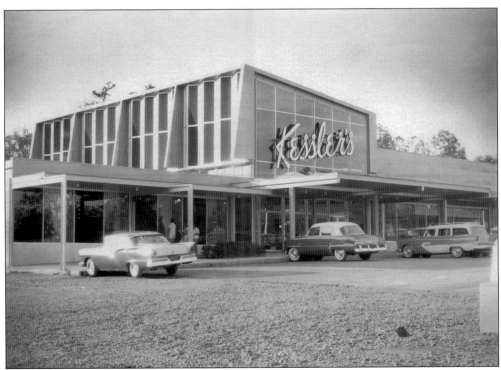

Pictured here is the north side of the Vestavia Hills City Center as it appeared in the 1950s. (Courtesy of the Bill Maddox family and Vestavia Hills City Hall.)

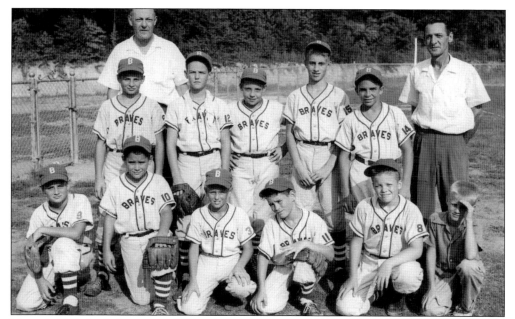

Vestavia Hills Little League in 1957 included the Braves. The Braves went on to become Shades Mountain Champs that same season. According to an article in the June 29, 1957, *Shades Valley Sun*, the Braves 18-0 shutout over the Yankees was due in large part to "Moxley's excellent two hit pitching," along with his two singles and a triple. Shown here from left to right are (first row) Pat Stevens, Jim Fosdic, Charles McGuire, Mike Fosdic, Tommy Spurrier, and bat boy Howard Kerr; (second row) Tommy Barker, Clinton Bolte, Claude Matthews, Bob Kerr, and Robin (Rob) Moxley; (third row) team managers Harry Bolte and Jack Stevens. (Courtesy of Rob Moxley.)

It was not until January 24, 1954, almost one year after "Charter Sunday," that the Vestavia Hills Methodist Church congregation had a building of its own. On that day, Dr. R. Laurence Dill Jr., then district superintendent, delivered the sermon in the chapel, which could accommodate up to 260 people. Prior to that point, the church held worship services at Vestavia Hills Elementary. (Courtesy of VHUMC archives.)

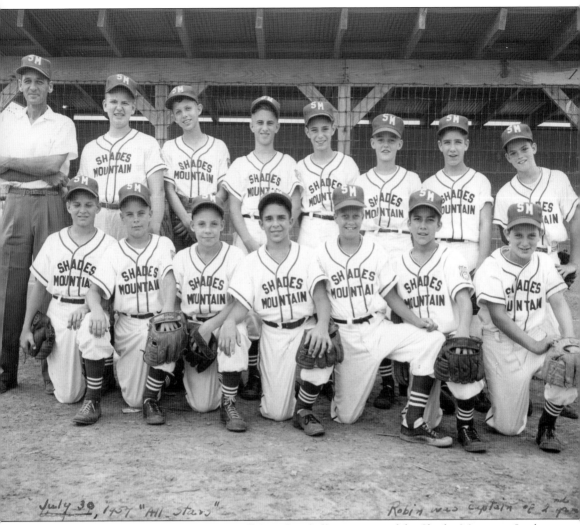

Shown here is the Shades Mountain All Stars baseball team, part of the Shades Mountain Little League, on July 30, 1957. Longtime Vestavia resident Robin (Rob) Moxley served as captain for the second game in the All Stars series. Pictured from left to right are (first row) Tommy Barker, Bill Rose, Claude Matthews, Rob Moxley, Charlie Fisher, Pierre Tourney, and Pat Stevens; (second row) manager Jack Skipper, Byron Chew, Skipper Hughes, Bob Kerr, Tommy Hooten, Clint Bolte, Tommy Faulkner, and Steve Hunt. (Courtesy of Rob Moxley.)

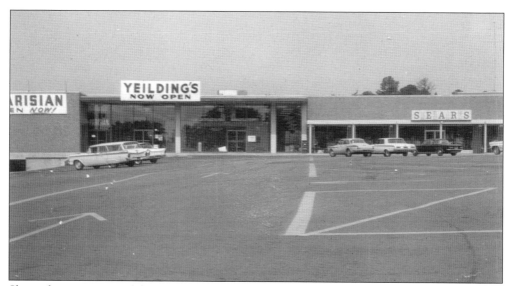

Shown here are some of the anchor stores of the Vestavia Hills City Center, including Parisian, Yeilding's, and Sears. While other tenants rotated throughout the years, Parisian proved to be a mainstay, remaining open until fall of 1997, when it relocated to The Summit. (Courtesy of the Bill Maddox family and Vestavia Hills City Hall.)

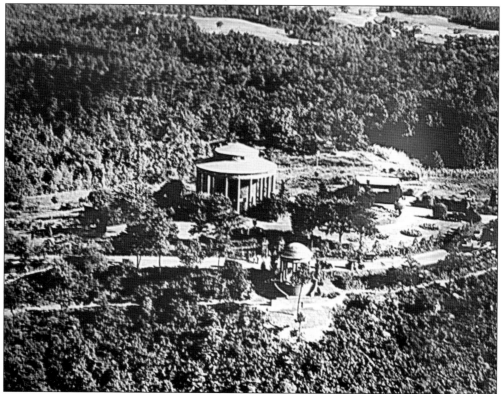

Shown here is an aerial view of the Vestavia Hills Baptist Church campus in the late 1950s. By 1966, the condition of the temple was such that, despite active resistance from area civic and historical groups, the church was forced to tear it down. (Courtesy of George Ritchey.)

Vacation Bible school intermediates and leaders from June 1958 included, in unknown order, Mrs. Baton, Smoky Davis, Drucilla Fulton, Mrs. Robinson, Martha Payne, and Mrs. Davidson. (Courtesy of VHBC archives.)

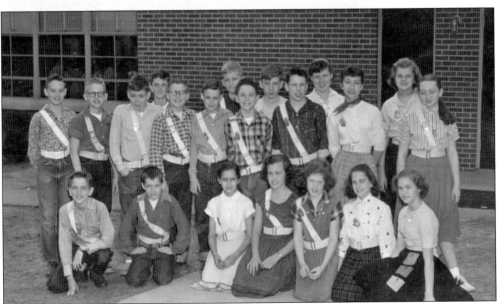

Shown here are the members of the 1955 safety patrol of Vestavia Hills School. They are, from left to right, (first row) Jac Chambers, Gene Bearden, Sylvia Bailey, Virginia Hodges, Kathy Ward, Mary Ann Thornton, and Janice Chase; (second row) Richard Hayes, Paul Murphy, Wade Houston, Jackie McDuff, Bill Hensley, Henry Hager, Donny Bridges, Charles Stewart, Tommy Burke, Steve Davis, Eloise "Lou" Falkner, Janet Tourney, Susan Hoffman, and Tana Lee (Vaughan) Thigpen. (Courtesy of Tana Lee Thigpen.)

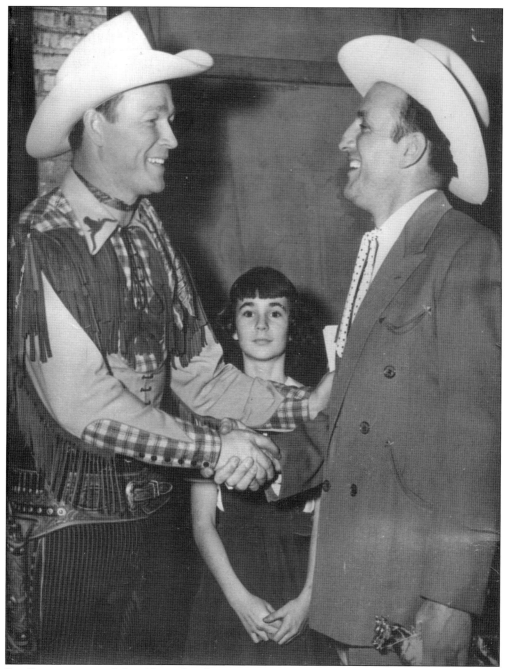

Roy Rogers visits with local legend and icon Happy Hal Burns. (Courtesy of Connie Burns.)

Shown here is a young Norma Breneman. The home behind her is a rental house of the Maddox family, where her eventual husband, Macky, and his parents lived next door to the Brenemans. When the two first began to notice each other, Macky would invite Norma to join him and his friends on their way to play neighborhood ball. The only girl, she would jump right into Macky's 1939 Dodge along with all of Macky's other friends. A close friendship between the two soon followed. (Courtesy of Norma Breneman Warren.)

Shown here are Norma Breneman (left) and her mother, Katherine Terrell Breneman, both of whom helped their family operate the Terrell family store from its opening through 1950, when the family sold the property to Mack and Lucille Warren. In 1954, the original white building was torn down to make way for a new four-lane highway. On one memorable date out with his then-girlfriend, Macky Warren remembers picking up Norma in his new car, a 1953 Ford. Norma wanted to take the car for a spin, and indeed she did—right along the construction rock piles on the side of the highway, bending the bottom of the door of Macky's car. (Courtesy of Norma Breneman Warren.)

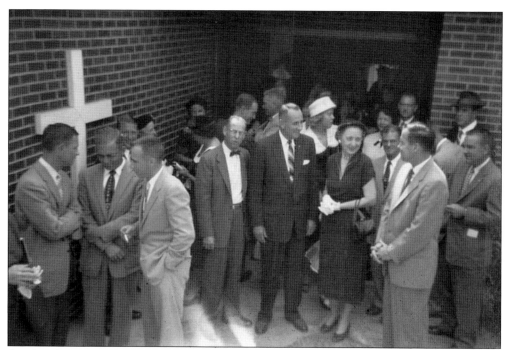

On October 7, 1956, Vestavia Hills Methodist Church hosted its first morning communion service. Prior to that point, the service had only been held in the evening. (Courtesy of VHUMC archives.)

The church's first youth fellowship group organized in June 1953. At that time, it included 13 members, with the following elected officers, who are not pictured here: Tommy Cain, president; Carol Williams, vice president; Bynum Waters, secretary and treasurer; Jane Waters, worship and evangelism; Jacqueline Smith, community service; Carolyn McClendon, recreation; and Sondra Anderson, missions and world friendship. (Courtesy of VHUMC archives.)

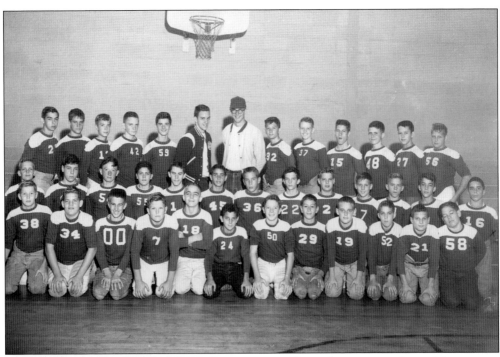

Shown here are members of the 1957 Sun Bowl team, sponsored by the YMCA. Area boys through the seventh grade were eligible to play in the recreational football league. Some Vestavia boys went on to have illustrious careers, including Champ Lyons, now an Alabama supreme court justice, and George Watson, an internationally recognized journalist and head of the ABC news bureaus in Washington, D.C., and London. (Courtesy of Rob Moxley.)

Shown here is A.I. Mote. Better known by his nickname, "Blue," he made his living as a farmer, selling fresh produce from his truck. Quite the character, Blue is remembered for adding a bit of levity to one particular Sunday morning worship service in Miller Chapel. Blue was called upon to adjust the light switch, located near his seat. Having fallen asleep during the sermon, Blue, alarmed, jumped up out of the pew and began to lead the congregation by praying out loud, which is what he assumed they had asked him to do. (Courtesy of SMBC archives.)

Long before Vestavia Hills Methodist Church ever had its own building, early church members gathered in the community center, which was essentially a small house near the Smyer house on Montgomery Highway. Mrs. Derward Smith served as the church school's first superintendent. At that time, the school included three children's classes and one adult class. During this time, the church purchased a five-acre wooded lot at the intersection of Kentucky Avenue and Eastwood Place from S.W. Strozier. (Courtesy of VHUMC archives.)

By 1956, church membership had swelled to 425, with 280 in regular Sunday school attendance. By the end of 1957, worship numbers nearly doubled. (Courtesy of VHUMC archives.)

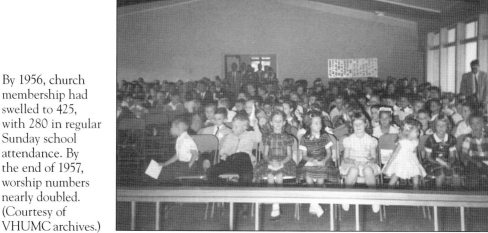

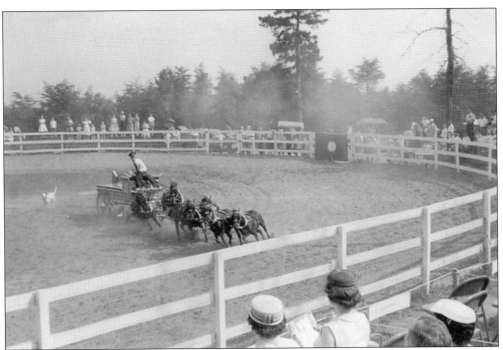

In June 1956, Vestavia Country Club hosted a horse show presented by Branchwater Country Club. The popular event included participants in formal riding attire using English saddles. Spectators took in the action from stands nearby. (Courtesy of Sondra Richardson.)

Mike Hamilton and Ouida Guthrie are shown here during their courting years, prior to their engagement. Mike's parents, Wilson and Dee Hamilton, owned and operated a business that sold compressed gas. They sold the product to a wide swath of customers—everyone from those who needed medical gases to lunch counters that needed the gas for their soda fountains. Dee also operated a ceramics business out of the Hamilton home. Mike eventually took over the family business from his father. (Courtesy of SMBC archives.)

Young Pat Reynolds rides his bike in the nearby community of Hoover. According to his longtime childhood friend and schoolmate Susan Copeland Kelley, Reynolds made it known early on that it was his dream to "live in one of those big houses across the mountain." He went on to serve as the city's mayor in the 1990s. (Both courtesy of Susan Copeland Kelley.)

Classmates David Snell and Pat Reynolds are shown here at Central Park School in 1953. (Courtesy of Susan Copeland Kelley.)

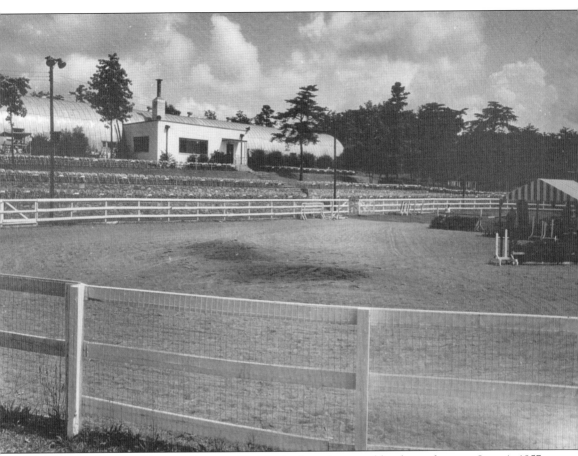

In its early years, Vestavia Country Club had a huge horse stable, shown here on June 1, 1957. When Beth McCord's great-grandparents passed away, her father sold their Oklahoma ranch and brought both his horse and his daughter's horse, Feste, to Birmingham. Beth remembers walking most days from Vestavia Elementary School East after school down to the country club to ride her horse. Sondra Richardson, who grew up on Beaumont Drive, just outside the country club, remembers the stables being located where guest parking is today. It was not uncommon for her to see people riding horses through the paths that intersected her backyard. The club employed a riding master and allowed individuals to board and rent horses. Many in Vestavia, including Sondra's family, rented horses and rode them around the edges of the 18-hole golf course. (Courtesy of Alvin W. Hudson.)

Bob and Lottie St. John, married at Vestavia Hills Baptist Church, were the first couple to host their wedding reception on the grounds of the former Vestavia Temple. Marsh Bakers, from the western section of Birmingham, did the catering. Lottie remembers it raining that day all around the church prior to the wedding, while not one drop fell on church property. (Courtesy of Bob St. John.)

Bob and Lottie St. John were married in the small sanctuary where the dance floor was when Vestavia Temple and Gardens operated as a restaurant. At the time, the pastor of Vestavia Hills Baptist Church was John Wiley, who told the couple that day that they had turned a pagan house into a house of worship. Today, their son Jim St. John serves as fire chief for Vestavia Hills. (Courtesy of Bob St. John.)

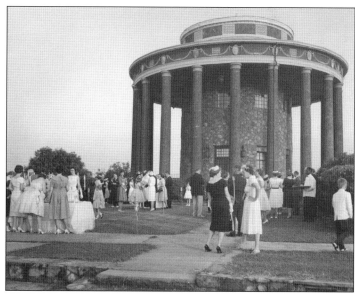

This photograph shows land being cleared in the distance at right for the construction of Brookwood Hospital. Norma Breneman remembers when she saw the first bulldozer and other equipment break ground there. She refers to it as one of the saddest days of her life, as it was in sharp contrast to the wilderness she found atop Shades Mountain as a young girl. (Courtesy of Pat Boone.)

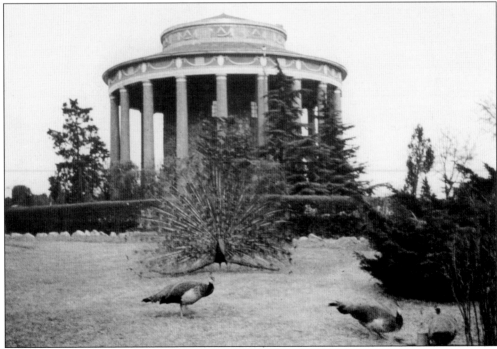

On March 24, 1958, Vestavia Hills Baptist Church purchased Vestavia Temple as its permanent location. With a nod to its location's history, the church's tagline in its early years was, "The Church with a View." (Courtesy of VHBC archives.)

On June 18, 1955, Macky Warren and Norma Breneman were married in a 7:00 p.m. candlelight service in the chapel of Vestavia Hills Methodist Church. The timing of the wedding had more to do with the fact that the chapel had no air conditioning and it was the middle of summer than anything else. Theirs was the first wedding held in the chapel, at that time the church's most formal room (there was no sanctuary). The reception had 150 guests, including Mayor V.L. Adams, and took place at the home of Norma's parents, complete with cake and punch. Following the reception, the couple departed that evening for Panama City in the 1955 turquoise and white Ford that Macky had given Norma as her graduation and wedding present. (Courtesy of Norma Breneman Warren.)

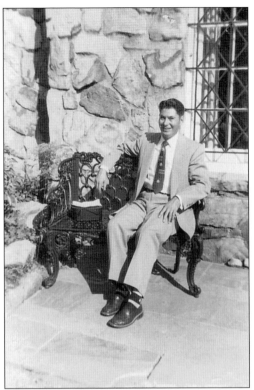

Jack Langston, shown here in October 1954, served as the minister of music at Shades Mountain Baptist Church from 1953 to 1956. After serving his nation for four years in the Air Force, during which time he fought in the Korean War, Langston was discharged as a staff sergeant in 1952 and then enrolled in Howard College (now Samford University). His role at the church coincided with his years spent in pursuit of his degree. The experience motivated him to pursue additional formal training. In 1959, he graduated from the Southern Baptist Theological Seminary, having earned a master's of sacred music degree. (Courtesy of SMBC archives.)

This is what the future site of Vestavia Hills Methodist Church looked like on March 30, 1958. Originally, at the suggestion of area developer Charles Byrd, church leadership had looked at a property along Southwood Road. As church membership swelled, senior leadership decided the lot was too small and instead arranged to build on this site, after purchasing the land from the Strozier family. (Courtesy of VHUMC archives.)

Polly Rose was a beloved Sunday school teacher at Shades Mountain Baptist. She, her husband, Dr. John Rose, and their son, Billy, lived on Shades Crest Road. John served on the pastor's home committee of the church as well. At this time, the home, known as the Pastorium, was located at 2573 Mountain Woods Drive. (Courtesy of SMBC archives.)

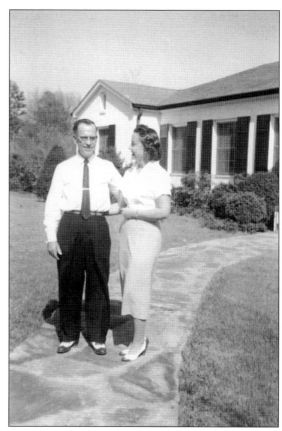

Though initial plans for Vestavia Hills Methodist Church started in the fall of 1950, it was not until Charter Sunday, April 5, 1953, that those plans were realized. After a ceremony officiated by Dr. J.H. Chitwood, the 114 charter members enjoyed basket lunches and other festivities. The church's name did not officially change to include the word "United" until 1968, when the Methodist Church and the Evangelical United Brethren Church merged to form the United Methodist Church. (Courtesy of VHUMC archives.)

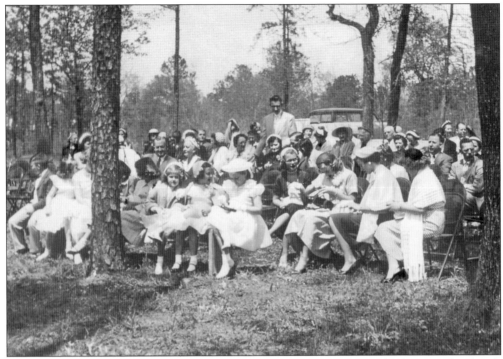

Early planning efforts leading up to Charter Sunday, including the establishment of a church choir and a children's membership class, ensured a successful day. In fact, the church welcomed 35 new members on this day alone. (Courtesy of VHUMC archives.)

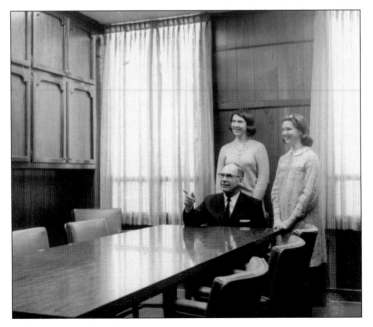

Howard Posey is seen here alongside his two daughters, Jackie (left) and Nancy. Posey worked at the former Birmingham Trust National Bank, which was in the shopping center that now holds Starbucks and Moe's. Posey helped several young couples, including Stanley and Tana Lee Thigpen, get their start. Stanley recalls being a young newlywed just out of the Air Force and having no credit history. Posey helped him obtain a car loan. (Courtesy of SMBC archives.)

Youth dances were a favorite draw for local teens. Seen here attending a youth dance sponsored by Vestavia Hills United Methodist Church is Jerry Schoel (far left) talking to Peggy Fisher. (Courtesy of VHUMC archives.)

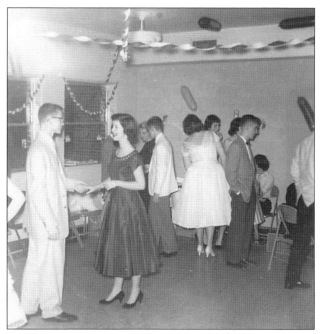

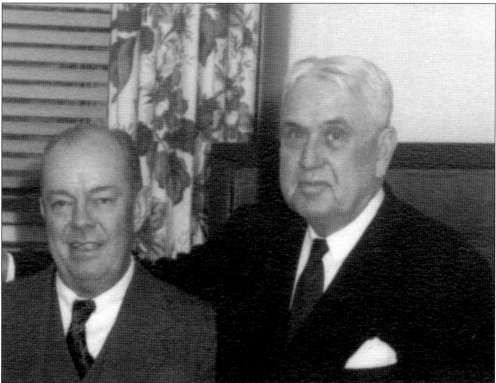

Frank Samford (left) and Dr. John Buchanan were active supporters of the work of Vestavia Hills Baptist Church. Both gentlemen had deep ties to the Alabama Baptist Association and to Samford University (formerly Howard College). They served as mentors to church leadership. (Courtesy of VHBC archives.)

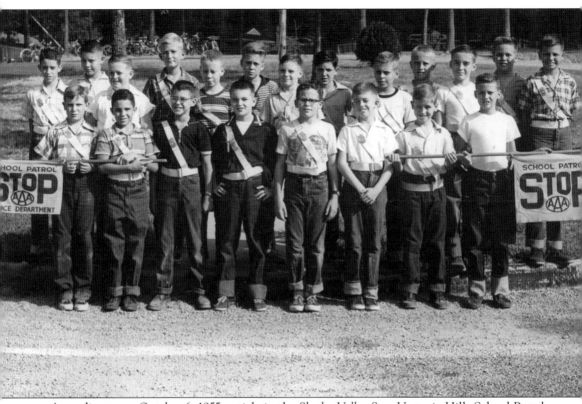

According to an October 6, 1955, article in the *Shades Valley Sun*, Vestavia Hills School Patrol members were "instructed and trained by Police Chief W.O. Haynes" and also had "written papers on "What Safety Patrol Means to Me and My School." Safety Patrol members were appointed by principal Helen O'Gara and supervised by Jois Evans. Jack Rhodes served as chairman. Shown here are members of one of the school's Safety Patrol teams. From left to right are (first row) Jack Rhodes, Robin Moxley, Dick Clayton, Jimmy Clark, David Knox, Doug Kirksey, Rusty Warmath, and Ricky Hamilton; (second row) Johnny Smithers, Lee Cowart, Squire Gwin, Charles McNeese, Ronny Davidson, Michael Garrett, Haynes O'Neal (captain), Danny Messamore, Donald Turner, Pat Real (captain), Lanier Townsend, Craig Cleaves, and Michael Warren. (Courtesy of Rob Moxley.)

Rev. Hugh O. Chambliss baptizes Dr. Pei Fei Lee in Miller Chapel. Lee remained an active member of the church. Miller Chapel was the eventual result of efforts made by Rev. William "Uncle Billy" Sellers, who first began pushing for a place to support children's spiritual development. The church has continued to benefit from the Sellers family legacy. In particular, their daughter-in-law Cassie played a pioneering role for young women in the church in its formative years. In 1926, when the church first established its Women's Missionary Union chapter, Cassie served as secretary. (Courtesy of SMBC archives.)

Choir members welcomed the musical accompaniment of the church's first electric organ in the fall of 1955, thanks to proceeds from an annual barbecue sponsored by the Women's Society for Christian Service. (Courtesy of VHUMC archives.)

From left to right, Joe Brown, Jack Knight, Nancy Brown, Judy Wiley, and Jerry French, along with French's children Janet and Jack, are seen here walking into Vestavia's town hall for worship around 1958. (Courtesy of VHBC archives.)

U.V. Goodwyn, shown here, who worked full-time as a financial services professional, put that experience to volunteer use by serving on many of the financial committees over the years of his attendance at Shades Mountain Baptist Church. (Courtesy of SMBC archives.)

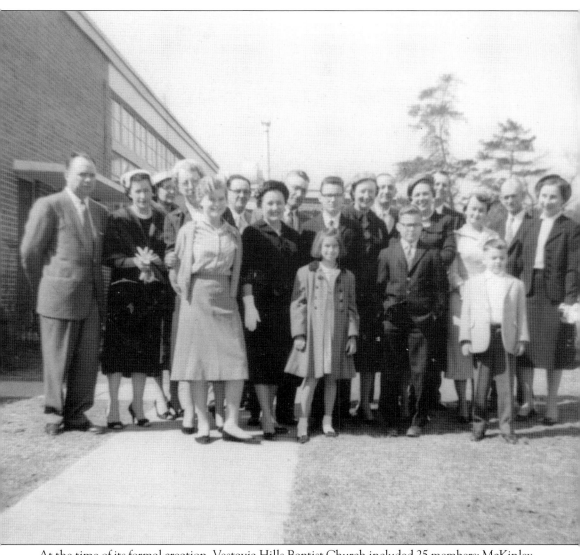

At the time of its formal creation, Vestavia Hills Baptist Church included 25 members: McKinley and Vera Anderson, Mr. and Mrs. James S. Brown, Mr. and Mrs. Joseph C. Brown, Charles E. Carney, Mr. and Mrs. Albert E. Casey, Mr. and Mrs. Grady Cunningham, Mr. and Mrs. W.B. Eidson, Milton Howell, Mr. and Mrs. H.J. Hager, Mr. and Mrs. W.C. Knight, Nancy Knight, Mrs. Claude M. Matthews, Mrs. Grace E. Peck, Mr. and Mrs. Harry Ruffin, and Mr. and Mrs. Robert E. Tate. A few of the church's original members are shown here on May 1, 1957, just before an early meeting in which, according to minutes from the Birmingham Baptist Association, "A Council was formed at the Vestavia Hills School Auditorium, for the purpose of constituting a Baptist church which was named The First Baptist Church of Vestavia Hills, but will be known as the Vestavia Hills Baptist Church." The document also included new member addresses and phone numbers, which were listed as five-digit party lines. Vestavia Hills School served as the second official meeting place for the congregation. The first official meeting place was the town hall. Among the early members pictured here are Mr. and Mrs. L.E. Sanders, Nancy Knight, Mrs. T.C. Sanders, Mrs. Mack Anderson, Henry J. Hager, Mrs. W.C. Knight, Joan Sanders, Henry Hager Jr., Mrs. Grady Cunningham, Harry Ruffin, Phillip Hager, Mr. and Mrs. W.B. Edison, Mack Anderson, Thelma Davies, Wayne Edson, and Mrs. Harry Ruffin. (Courtesy of VHBC archives.)

Pastor Hugh Chambliss served at Shades Mountain Baptist Church from 1951 until 1961. He is seen here with his wife, Faye, and their children, Janet and Dale Lynn. During Chambliss's time as pastor, Shades Mountain Baptist used the tagline: "The Church with a Warm Heart and a Friendly Spirit, Where You Are Never a Stranger." (Courtesy of SMBC archives.)

Faye Chambliss played a very active role in Shades Mountain Baptist Church. One of the enduring events she initiated is shown here: the "Come As You Are" breakfast series. (Courtesy of SMBC archives.)

Sibyl Temple is seen here in the 1950s. By the end of the decade, this property had been acquired by Vestavia Hills Baptist Church. (Courtesy of Brent Nielsen and Patti Westbrook.)

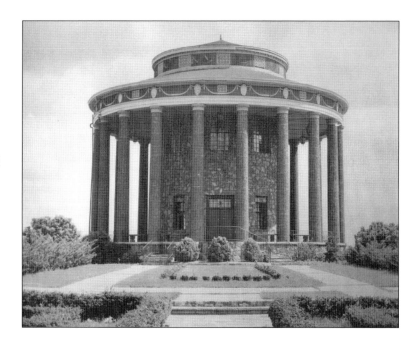

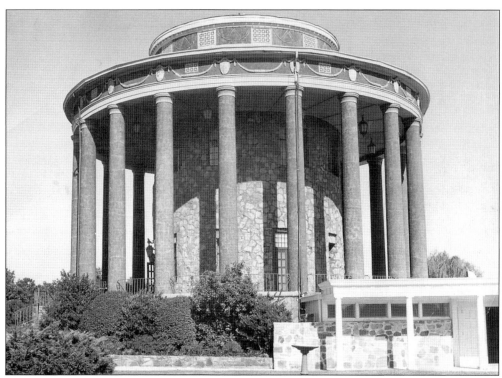

The Vestavia Temple Garden and Restaurant is seen here at the time it was purchased by the church in 1958. The portico in the foreground still stands. (Courtesy of VHBC archives.)

This is the view from Montgomery Highway looking south from the original Joe's Ranch House. Joe's was the city's first—and, for quite some time, only—private dinner club. It thrived in part because it provided an exclusive environment without the moonshine and the nightclub atmosphere that characterized other parts of the city. (Courtesy of Alvin W. Hudson.)

This is Montgomery Highway looking south from the cloverleaf of Lakeshore Drive. According to Norma Breneman Warren, Lakeshore Drive was so named because it paralleled the northern shore of Edgewood Lake, an artificial lake created by damming Shades Creek at Green Springs Highway. (Courtesy of Alvin W. Hudson.)

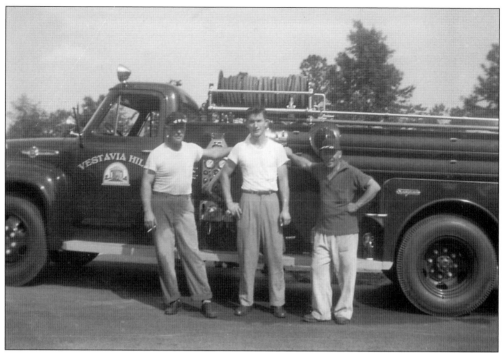

In 1953, Vestavia Hills established its first volunteer fire department. Among the first firefighters were, pictured here from left to right, Bob Monroe, Bill Maddox, and Pete Owens. The new fire truck was a major point of pride for Mayor V.L. Adams. At his directive, the newly minted firefighting team rode around the city to show off the new truck. With three on the tailgate and two in the cab, the volunteer firefighters were traveling past where the U-Haul now stands when the drive shaft came out, tearing up the brake system and causing the crew to roll 2.6 miles before they came to a complete stop. (Courtesy of the Bill Maddox family.)

Shown here at a youth gathering sponsored by Shades Mountain Baptist Church are, among others, Jim Edwards and Barbara Sharp (second and third from left) and, on the far right, Polly Sharp and Pei Fe Lee. (Courtesy of SMBC archives.)

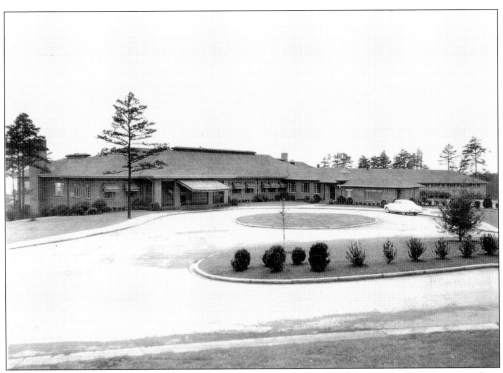

Vestavia Country Club is seen here from the front in 1953. The club accepted charter members through 1955, including Henry S. McReynolds, one of the city's first councilmen. On June 1, 1955, he became the club's 310th member. (Courtesy of Pat Boone.)

Rev. Dr. John Wiley and his family were regular visitors to Vestavia's town hall in the late 1950s. While Vestavia Hills Baptist Church was being formed, the city's town hall became its default meeting place until a proper house of worship could be established. (Courtesy of VHBC archives.)

In 1958, Rev. Dr. John Wiley stands at the pulpit in the former dining room of the Vestavia Temple Restaurant, which then served as the sanctuary of Vestavia Hills Baptist Church. (Courtesy of VHBC archives.)

The Halloween carnival was started in 1957 by Carole Faught Vines and Billie Brady, the mother of Beth Brady McCord, who went on to teach drama at Pizitz Middle School. This carnival eventually became the fall festival. (Courtesy of Beth Brady McCord.)

Ernest Walker Sr., pictured here in 1956 with his wife, Ann, and granddaughter Lisa, was one of the charter members of Shades Mountain Baptist Church, where he also served as a deacon. Ann served as church historian. Their grandson Dirk Walker still lives in Vestavia Hills today, where he has built a successful career as an artist. (Courtesy of SMBC archives.)

Shown here playing in her yard is Beth Brady McCord. The Brady home was located on the corner of Southwood Road and Highway 31. The highway was originally the truck route to Montgomery. When the southbound lane of Highway 31 was built in 1953, the highway department took a large section of McCord's childhood home for the roadway. Prior to that, the Brady property extended out to where the median of Highway 31 is today. (Courtesy of Beth Brady McCord.)

Hilton Logan served in many lay leadership roles for Shades Mountain Baptist Church. Upon hearing the news of Miller Chapel being torn down, Logan was insistent on having his photograph taken on the church steps. The Logan family lived off of Lorna Road in the Monte D'Oro neighborhood. His daughter and son-in-law Yvonne and Bill Jenkins remain in the area today, where they are partial owners of some of the local Dunkin' Donuts franchises. (Courtesy of SMBC archives.)

The Brady home originally had a screened-in front porch. When their only daughter, Beth, began dating, the front porch became a point of parent-child contention. During one memorable Christmas, Beth's parents gave her the columns and tore down the screened-in portion. (Courtesy of Beth Brady McCord.)

Shown here are a few of the high school girls who participated in the 1955 coronation festivities held at Shades Mountain Baptist Church. From left to right are Miss Crane, Miss Strozier, Miss Guthrie, Miss Houston, and Miss Falkner. (Courtesy of SMBC archives.)

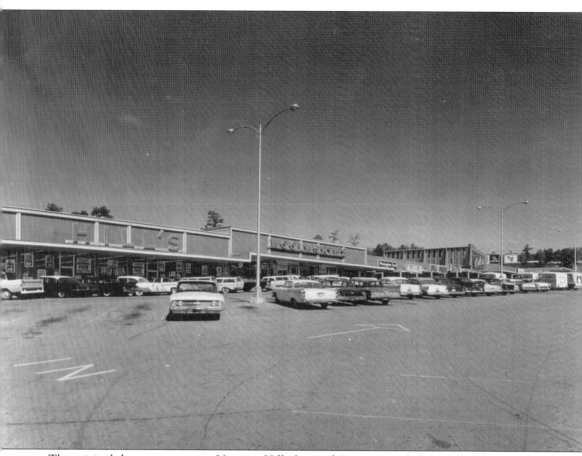

The original shopping center in Vestavia Hills featured 21 stores, including Hill's Supermarket; Woolworth's; Snow's Cards and Gifts; Birmingham Trust National Bank; Lea Drug Co., which featured a cafeteria and a soda bar in addition to drug, cosmetic, gift, and photograph departments; Vestavia Barber Shop; and Bell Bros., a family shoe store. Additional merchants included Fashion Post; Kessler's, known as a specialty destination for women's clothing; Vestavia Hardware & Home Supply; Yeilding's Department Store; Perfection Laundry; Vestavia Bake Shoppe; Western Supermarket; Gene 'N Dud's Men's Wear; and Klein's Vestavia Flowers. The shopping center opened with much fanfare, and drawings gave attendees a chance to win a Starliner Over-Nighter boat, courtesy of Adwell Tire & Marine Supply; an English Ford, courtesy of Vulcan Lincoln Mercury Inc.; and even a free pony with a saddle. (Courtesy of Pat Boone.)

Three

A New Community
1960 and Later

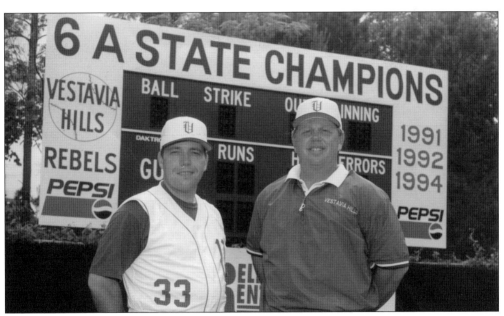

Coach Sammy Dunn, left, stands in front of the Rebels scoreboard with one of his assistant coaches, Cas McWaters. As chronicled in the 2001 book *Dynasty on the Diamond* by Coach Dunn and Ron Ingram, the Dunn era of Vestavia Rebels baseball has left an undeniable legacy. Seven consecutive 6A title wins set Dunn apart as one of the most successful prep baseball coaches nationwide. Underscoring this was his 23-season record of 547-143. Several Rebels also went on to successful careers in major league baseball. McWaters left his own legacy on the high school and the community. A product of the school system, he grew up to coach and teach chemistry at Vestavia and also served as its highly regarded principal. Blessed with a stellar singing voice, McWaters is also recognized for the vocal talent he's shared at everything from I Love America Day to other civic events throughout the city. (Courtesy of Linda Forsythe Dunn.)

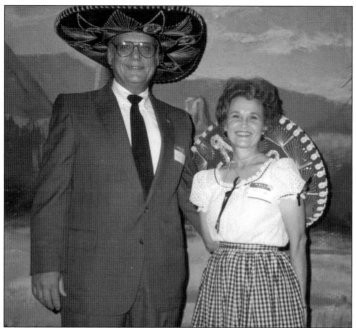

Lee Pilleteri, 1990–1991 president of the Vestavia Hills Chamber of Commerce, is shown here with longtime Vestavia Hills resident and civic volunteer Frances Poor, at the Business After Hours event held September 24, 1990, at the former La Bamba restaurant. The evening, which featured costumed waiters and guests, had a $5 attendance fee, with all $600 in proceeds being donated to the Sibyl Temple Fund. (Courtesy of Vestavia Hills Chamber of Commerce.)

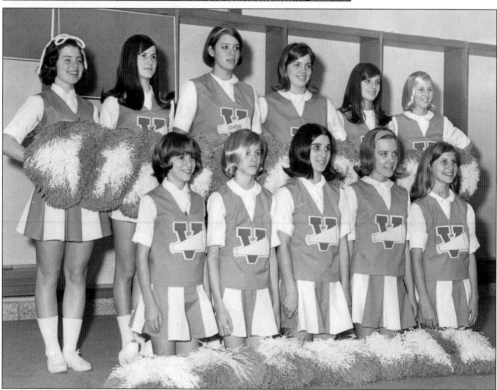

Shown here are members of the 1968–1969 Vestavia Hills Junior High cheerleading squad. From left to right are (first row) Pam Stokes, Nancy Tremain, Jeannie Wuska, Susan Johnson, and Carolyn Carroll; (second row) Wanda Allen, Sharon Pollard, co-head Carolyn Baumgartner, Sally Sears, co-head Patti Montsalvatge, and Patty Tremain. (Courtesy of Diane Ray.)

From left to right are three members of the 1990–1991 Vestavia Belles, the official hostesses of the city: Cindy Chancey, Ginny Gammill, and Malia Rusk. (Courtesy of Vestavia Hills Chamber of Commerce.)

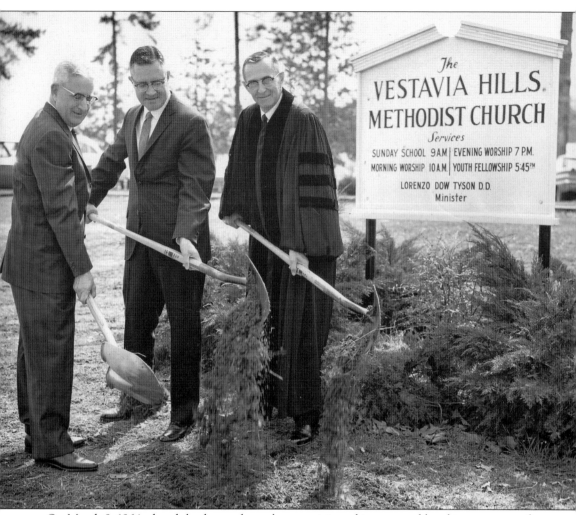

On March 8, 1964, church leaders and members participated in a ground-breaking ceremony for Vestavia Hills Methodist Church's future sanctuary. (Courtesy of VHUMC archives.)

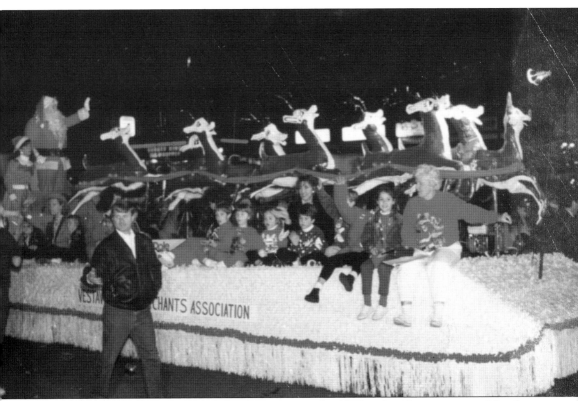

The city's annual Christmas Parade has its origins in the 1980s, when it was supported by the now defunct Vestavia Hills Merchant's Association. An elaborate affair, the early parades began at the top of Highway 31 by Sybil Temple and the Church of the Nazarene. Live reindeer were a special highlight of the event, which also included more than a dozen lavishly decorated floats, and live music. (Courtesy of Vestavia Hills Chamber of Commerce.)

At the time Buddy Anderson was named head football coach at Vestavia Hills High School, he had just completed his sixth season working with the Rebels as assistant coach. At 28 years old and with a degree from Samford University instead of one of the big state schools, Anderson's selection was met with skepticism by some. Adding to that was the fact that the 1978 Rebels, then a class 4A team, only had two returning starters. Despite a losing start, Anderson's team turned it around with their first victory at Hewitt-Trussville. From there the team advanced to the state finals, where they ultimately lost to Jeff Davis. The team had earned a reputation for turning around seemingly impossible odds on the field, and as a result were nicknamed "The Cardiac Crew." (Courtesy of Linda Anderson.)

Taking inspiration from the city's 1991 Litter Awareness Week, three Vestavia Hills residents, from left to right, Margaret Towns, Nadine Cox, and Pat Linton, dressed the part to increase participation in clean-up efforts. (Courtesy of Vestavia Hills Chamber of Commerce.)

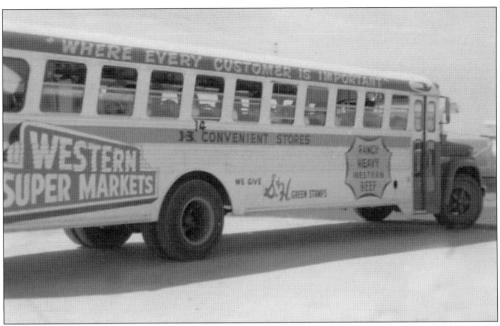

One of the first grocery stores on the mountain was the Western Super Market. It stood where the PetSmart stands now on Montgomery Highway. Until that point, Vestavians found the nearest grocery to be Hill's Supermarket, down in Homewood, which is now a Piggly Wiggly. (Courtesy of VHBC archives.)

In 1991, the Vestavia Hills Chamber of Commerce amended criteria for its annual Citizen of the Year Banquet. That amendment allowed for the selection of both a male and female winner. Shown here are Pat Mitchell and Ray Harris, 1991 Citizens of the Year. Mitchell is remembered by many as the face of "Auntie Litter," who advocated hands-on environmental education to children throughout Vestavia Hills and Alabama. Harris generously donated his services (worth over $20,000) to help renovate city hall and design the outdoor amphitheater of Pizitz Middle School and the nature trail behind Vestavia Hills Elementary Central School. (Courtesy of Vestavia Hills Chamber of Commerce.)

On August 26, 1971, the day before teachers reported back for the new school year, five coaches had just left a favorite lunch spot, Britling's Cafeteria, on their way back to school for afternoon football practice. The second car held Coaches Phil Puccio, Cooper Ray, and Tommy Ward, who were killed when their car was struck by an 18-wheeler that had lost its brakes. Shown here from left to right are Coach Tommy Ward, Coach Cooper Ray, and Rebel David Jones. (Courtesy of Diane Ray.)

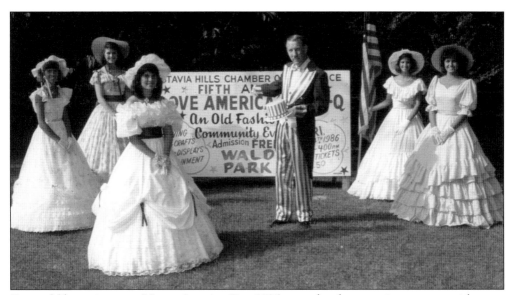

On its fifth anniversary, I Love America Day 1986 proved to be a roaring success, with more than 7,000 in attendance during festivities held at Wald Park. Entertainment included everything from Scottish dancers to sky divers. Mayor Pat Reynolds made for a convincing Uncle Sam. He is shown here with five of the Vestavia Belles who also turned out for the event. From left to right, the young women are Katie Matuszak, Gail Smith, Jackie Wuska, Jenny Murchison, and Nancie Barr. (Courtesy of Patricia Barr and the Vestavia Hills Chamber of Commerce.)

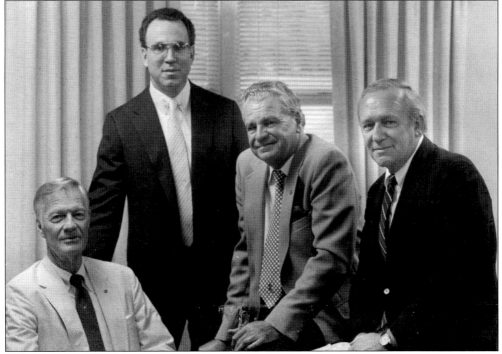

Members of the 1984–1988 Vestavia Hills City Council are, from left to right, president Fred McCrory, Henry Battle, president pro tem Bill Williams, and Charlie Davis. Councilman Sherman Suitts is not pictured. (Courtesy of Vestavia Hills Chamber of Commerce.)

Shown here is Sara Wuska on the evening she was elected mayor of Vestavia Hills. Wuska served the city in this role from 1984 to 1988. (Courtesy of Sara Wuska.)

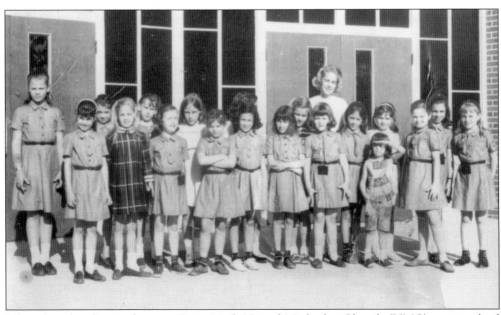

Like other churches in the area, Saint Mark United Methodist Church (UMC) was involved in sponsoring local Scouting troops. In 1965–1966, the church sponsored the Girl Scout troop pictured here. Ann Crini served as Scout leader. (Courtesy of Saint Mark UMC archives.)

As part of its ongoing fundraising efforts, the Women's Christian Service Council of Saint Mark United Methodist Church held events like the popular annual bazaar, shown here in October 1972. (Courtesy of Saint Mark UMC archives.)

George Neihbur, shown here on the left, served as assistant principal of VHHS under the leadership of principal Michael Gross, from 1985 to 1999. After coaching basketball and earning his administrative degree, Neihbur took an unexpected career turn, joining the FBI. During that stint, Neihbur found himself accepting doughnuts and coffee from Mrs. Jimmy Hoffa while he was on a stake-out outside the Hoffa home. (Courtesy of Michael Gross.)

Before he joined the coaching staff at Vestavia Hills Junior High, Phillip Puccio enjoyed a successful high school career as a first-string end at Ensley. According to his sister, Marietta Juliano, Puccio showed remarkable courage and grit when, just one week after their mother's untimely death, he stepped up to aid his team. As it happened, the team's senior All-City starting defensive end had endured a season-ending knee injury. Though Phillip was only 15 years old, and all of 150 pounds, he was asked to start the game that Friday. Puccio's performance in that game earned him the distinction of "Lineman of the Week" by *The Birmingham News*. In the words of Marietta, "he played with a lion's heart." (Courtesy of Marietta Juliano.)

Shown here at the 1992 Alabama-Auburn game are Vestavia Hills High School alumni who went on to serve their universities as cheerleaders, Auburn Plainsmen, and War Eagle Girls. From left to right are (first row) Daree Serrano, Missy Chandler, Delana Serrano, and Libby Halbrooks; (second row) Martha Juneman, Scott Porter, David Cicero, Tracy Bresler, and Steven Gill. (Courtesy of Diane Ray.)

During the 1977 Dogwood Parade, part of the Vestavia Hills Beautification Board's annual Dogwood Festival and Trail, Cindy Chancey was named Dogwood Princess, and Trey Brooks was named Dogwood Prince. Under the theme "Dogwood Dazzle," pageant participants wore outfits from former department store Yeilding's, with clothing selected by Yeilding's fashion coordinator Ethel Barnett. Cindy is shown in a one-piece dress known as the "Mary Louise," which at the time retailed for $24. Trey is shown wearing a three-piece "Doespun" suit, with a 1977 price tag of $33. At the time, Yeilding's operated four stores in the greater Birmingham area: downtown, Five Points West, Gardendale, and Vestavia Hills. (Courtesy of Cindy Chancey Tyus.)

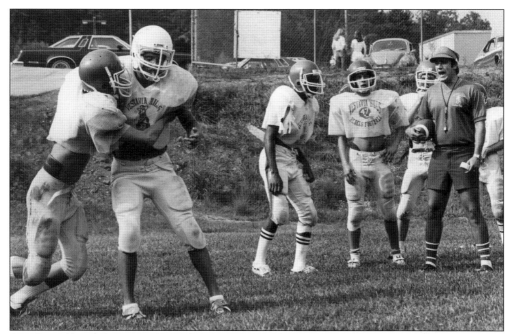

Coach Buddy Anderson is shown here at far right during a one-on-one tackle drill. In October 2014, after more than 36 years of leading the Rebels football program, Anderson became the winningest football coach in Alabama high school history, with 310 wins. He spent nearly four decades shaping the program. Unlike the coaches of his youth, who were always after the next big opportunity, Anderson made it a priority to commit to one program and build it up. That came out in Anderson's job interview, and led then head coach Mutt Reynolds to offer him the job on the spot. (Courtesy of T.E. Langston.)

Shortly after Pizitz Middle School was renamed, Norma Warren, then an active member with the Birmingham Ballet, helped create a cotillion. Birmingham Ballet leadership thought it would be a good idea to foster events encouraging youth all over the Shades Mountain area to learn to dance. Shown from left to right are Margaret Ann Renneker, one of the Pizitz coaches, Norma Warren, and a Pizitz student. (Courtesy of Norma Breneman Warren.)

Shown here are several members of the Pizitz family in 1981, with Hortense Pizitz seated at front. The remaining family members pictured are, from left to right, Richard Pizitz Jr., Michael Pizitz, Nancy Nagrodzki (seated next to her grandfather), Richard Pizitz Sr., Merritt Pizitz, and Jeff Pizitz. (Courtesy of Pizitz Middle School.)

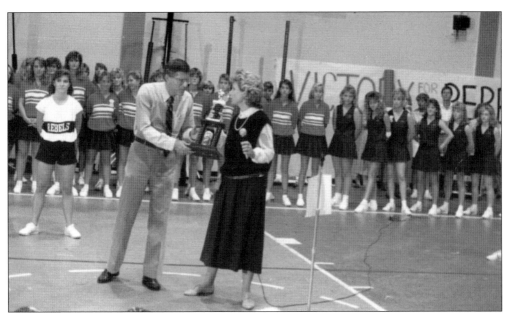

Presentation of the Spirit Stick was a huge tradition during Vestavia Hills High School pep rallies, particularly in the 1980s. Principal Michael Gross is shown here during a pep rally in the fall of 1986, awarding the Spirit Stick to club sponsor Linda Rainer, also a teacher of 10th grade English. Following the pep rallies and school dismissal, Principal Gross had a tradition of walking the school parking lot, picking up any spare pennies he could find that were facing heads up. The pennies were placed in the school mailbox of Coach Buddy Anderson, signifying confidence in the Rebels' chances of winning the game that evening. (Courtesy of Michael Gross.)

Principal Michael Gross, along with his beloved English sheepdog, Lady, and students are waiting for buses to take them to the start of the annual homecoming parade route, which started at the intersection of Garland Drive and Lime Rock Road. In 1985, administrators chose the location after Highway 31 was ruled out due to heavy traffic. (Courtesy of Michael Gross.)

In 1961–1962, Vestavia Hills School included three first-grade classrooms. This is the first-grade class of Mrs. Inez Fountain. (Courtesy of VHEE archives.)

Pat Mitchell, known around the community and statewide for her beloved Auntie Litter character, is shown here with area students during one of the many recycling and environmental awareness events held in the city. (Courtesy of Vestavia Hills Chamber of Commerce.)

Steve Johnson and Lucy Baxley pay a visit to the Vestavia Hills Plaza Shopping Center. (Courtesy of Vestavia Hills Chamber of Commerce.)

At the end of each school year, the local Kiwanis Club held a reception honoring top high school athletes. In 1992, Wade Kaiser, shown here at center with Principal Michael Gross (left) and men's basketball coach George Hatchett, was honored for being the top high school basketball player in Jefferson County. (Courtesy of Michael Gross.)

Six VHHS students were honored during the May 1990 Vestavia Hills Chamber of Commerce luncheon. From left to right are chamber president Lee Pilleteri, Suzy Gajewski, Christian Birkedal, Kim Tucker, David Meezan, Brandon Falls, Zack Dollar, and awards chairman Kay Tipton. (Courtesy of Vestavia Hills Chamber of Commerce.)

Young children perform a choral ensemble at Vestavia Hills Baptist Church in 1960. The church's music ministry has been a mainstay since the organization's inception. (Courtesy of VHBC archives.)

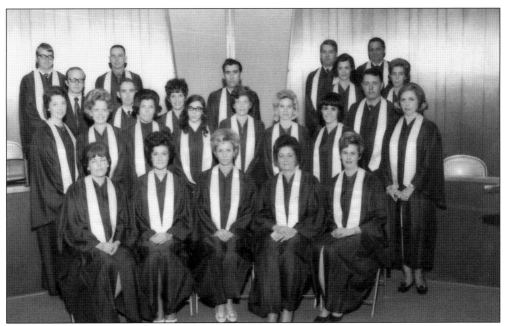

The choir of Saint Mark United Methodist Church posed for this photograph. Among those pictured are Reba Williams, C.A. Hartsell, Betty Watkins, Lillian Jones, Juanita Magneeson, Lullia Hunt, Sammie Welden, Donna Jenkins, Judy Weisman, Mary Pugh, Shirley Webb, Ed Roberts, Betty Murphy, Jack Weisman, John Campbell, John Walker, Leo Hunt, Martha Yeilding, and Harold Page. (Courtesy of Saint Mark UMC archives.)

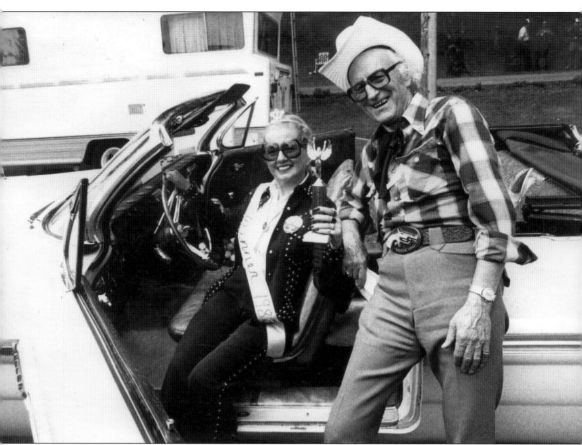

Shown here are Happy Hal Burns and his wife, Connie, also known as "Mrs. Happy." Happy Hal is credited with writing more than 100 songs. One memorable title, "Cow Town," was re-recorded by George Strait. (Courtesy of Connie Burns.)

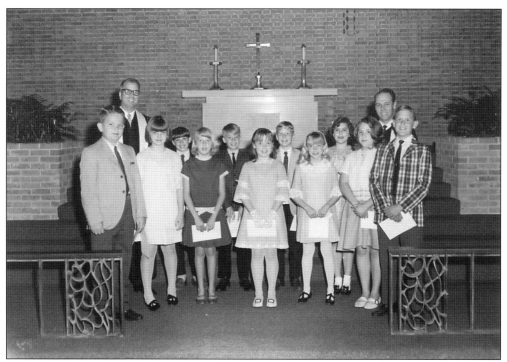

Shown here is the Vestavia Hills Methodist Church confirmation class of April 2, 1967. Confirmation typically takes place during the seventh grade. (Courtesy of VHUMC archives.)

In 1988, the Vestavia Merchant's Association advertised its annual Christmas Festival and Parade with this can't-miss hot air balloon. Flanking the festive balloon are, from left to right, Glenn Peacock, Lee Pilleteri, Mayor C. Pat Reynolds, mayoral assistant Lou Falkenberry, and chamber president Patricia Barr. (Courtesy of Vestavia Hills Chamber of Commerce.)

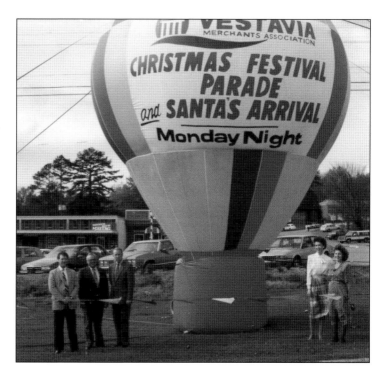

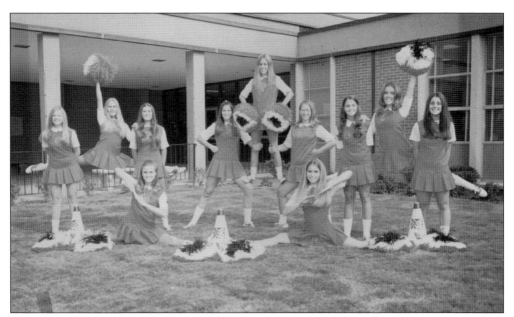

Shown here are the 1971–1972 Vestavia Hills Senior High cheerleaders. From left to right are (first row, on ground) Beverly Drake and Karen Steiner; (second row) Debbie Lauber, Donna Duval, Sharon Pollard, co-head Sue Brennan, Beverly Kimble, head Cindy Phillips, Melanie Adderhold, Susan Johnson, and Jeannie Wuska. (Courtesy of Diane Ray.)

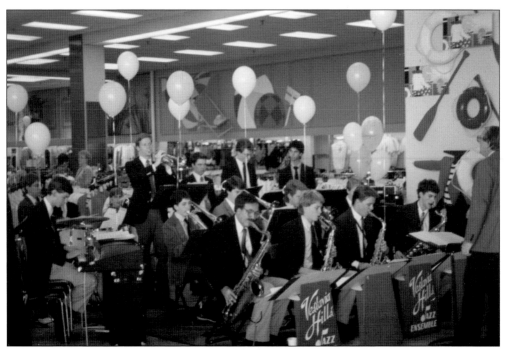

Shown here is the Vestavia Hills Jazz Ensemble delivering a performance in the main shopping area of Parisian. (Courtesy of Vestavia Hills Chamber of Commerce.)

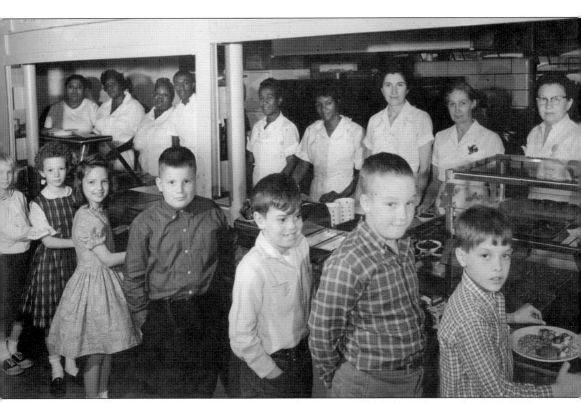
Students are seen here in line at the cafeteria of Vestavia Hills School during the 1961–1962 school year. (Courtesy of VHEE archives.)

In May 1991, VHHS moved commencement from Thomson-Reynolds Stadium to Shades Mountain Baptist Church. Principal Michael Gross and Coach Buddy Anderson, members of the church, were instrumental in making the location change a reality. Shown here during one of the church-hosted graduations are, in front from left to right, Superintendent Carlton Smith, Assistant Principal Sam Short, and Principal Gross. During this particular graduation, several students pulled a prank on Principal Gross. Knowing about his penny collecting habit, the students each slipped a penny roll into his hand as he handed them their diplomas. Though his suit pockets were practically overflowing with pennies by ceremony's end, the principal got a kick out of their harmless trick. (Courtesy of Michael Gross.)

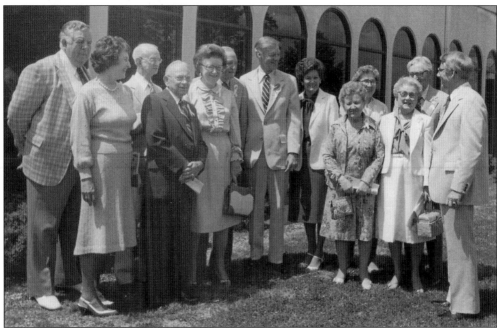

The 25th anniversary of Vestavia Hills Baptist Church, held on May 2, 1982, was attended by 13 charter members: Walter Hentz Jr., Ann Hentz, McKinley Anderson, W.E. Reedy, Floyce Cunningham, Grady Cunningham, Fred McCrory, Sybil McCrory, Rozzie Batson, Thelma Dodd, Catharine Hager, Henry J. Hager, and Dr. C. Otis Brooks. (Courtesy of VHBC archives.)

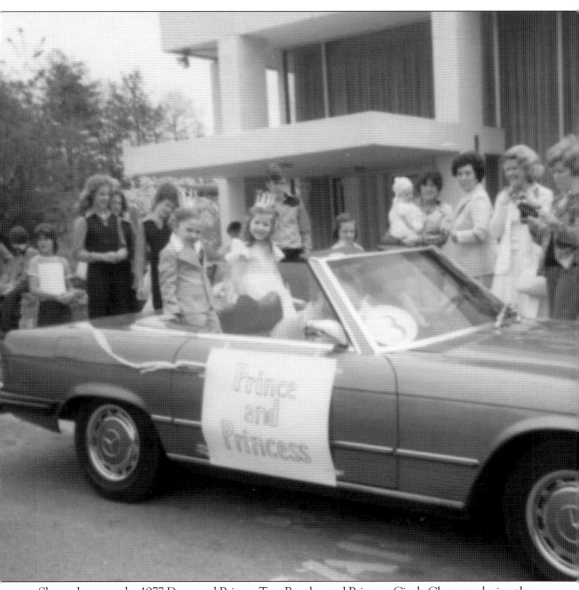

Shown here are the 1977 Dogwood Prince, Trey Brooks, and Princess Cindy Chancey, during the Dogwood Festival and Trail parade. The 1977 Dogwood Fashion Show, a benefit for the Vestavia Hills Beautification Board, included not only four- and five-year-old princes and princesses, but also area models Karen Gillis, Mary Jane Monroe, Sue Laughlin, Ginger Sharble, Glenyl Poer, and Cindy Haydock, as well as male models Tommy Lewis, Jack Grace, Jabo Waggoner, and Larry Blakeney. The event took place April 6 at the Celebrity Dinner Theatre, complete with a dance performance by Rick and Tammy Towns, and piano and organ music by Carolyn Jones. The Dogwood Festival and Trail, established in 1964, remained a beloved part of the city's history until 2011, when a series of tornadoes severely damaged the bounty of dogwoods throughout Vestavia Hills. (Courtesy of Cindy Chancey Tyus.)

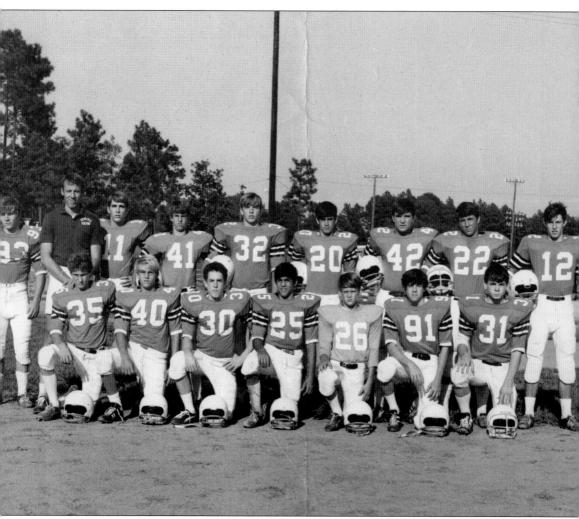

Shown here is the 1970–1971 Vestavia Hills Junior High football team, coached by Cooper Ray. In addition to football, Coach Ray also worked with the school's baseball and basketball programs. A skilled athlete, Ray played basketball for Ensley High and intramural basketball at Auburn University. After majoring in physical education at Auburn, he married Diane Higginbotham and took the coaching job at Vestavia. During the summers, the couple enjoyed lifeguarding. While she worked at the Children's Fresh Air Farm, he served as a lifeguard at Vestavia Country Club. (Courtesy of Diane Ray.)

Diane Higginbotham Ray served as sponsor of Vestavia Hills cheerleaders, first at the junior high level and then at the high school level, every year since 1968. She came to Vestavia Hills Junior High upon graduation from the University of Montevallo, where she majored in physical education. After serving the school system for 25 years, Ray deservedly took retirement in 1993. (Courtesy of Diane Ray.)

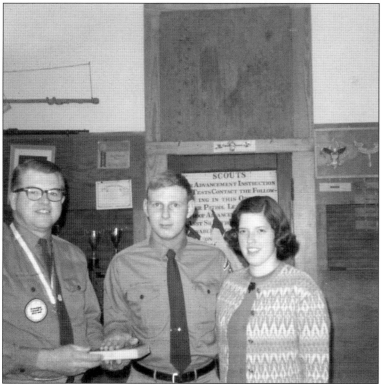

Vestavia Hills Baptist Church has played an active sponsorship role with the Greater Birmingham Scout Association. Shown here from left to right are former Vestavia Hills Boy Scout troop chairman Ralph Wood, Scoutmaster Eddye Lawley, and Eddye's wife, Mimi. (Courtesy of VHBC archives.)

Maxine and Steve Ammons are shown here at World Communion Sunday. In 2014–2015, Ammons served his city as mayor pro tem. (Courtesy of VHBC archives.)

Rev. John Wiley, shown here with the local Boy Scout troop prior to one of their camping trips, was a proponent of the Boy Scouts of America. He was instrumental in helping establish a sponsorship of a local Vestavia Hills Boy Scout program in partnership with Vestavia Hills Baptist Church. (Courtesy of VHBC archives.)

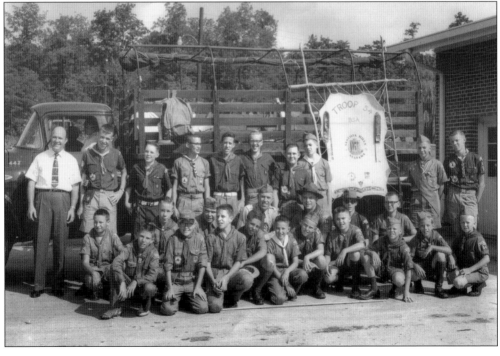

During the city's annual I Love America Day festivities, Tilden Chancey (second from right) always set up a refreshment stand for guests, complete with giveaways and prizes. On hand to help him serve the crowd were, from left to right, Ashlee Maples, daughter Pam Chancey, and, in Belle attire, daughter Cindy Chancey. (Courtesy of Cindy Chancey Tyus.)

From left to right, Lottie St. John, Janelle Williams, Max Gartman, and Elbert Williams were a few of the young married families in the early years of Vestavia Hills Baptist Church. (Courtesy of VHBC archives.)

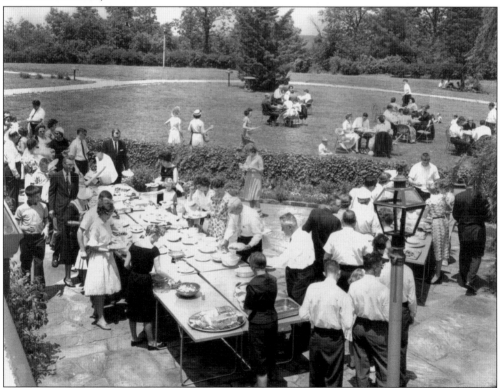

George Ward's original Sybil Temple, repurposed as the Vestavia Temple Garden Restaurant, remained intact for 13 years after Vestavia Hills Baptist Church purchased the property as its future home. During that time, the congregation enjoyed the grounds, with picnics and other outdoor events each autumn and spring. (Courtesy of VHBC archives.)

Dr. and Mrs. Max Gartman made history at Vestavia Hills Baptist Church by becoming the youngest marriage in the history of the church, as recorded in March 1968. (Courtesy of VHBC archives.)

In 1995, the Vestavia Hills High School women's basketball team, coached by Fran Braasch, won the state championship. Principal Michael Gross is shown here during the assembly where the team was honored for their achievement. (Courtesy of Michael Gross.)

In 1994, Brandi Magee, daughter of Tom and Vicki Magee, was crowned Miss Dogwood. Magee's crowning marked the 31st anniversary of the city's annual Dogwood festivities. (Courtesy of Brandi Magee Vickers.)

During the 1988–1989 school year, Vestavia Hills High School retired the baseball jersey of Jay Waggoner. Waggoner had achieved the highest batting average, the most hits, and the best fielding percentage while remaining at the top of his class academically. (Courtesy of Michael Gross.)

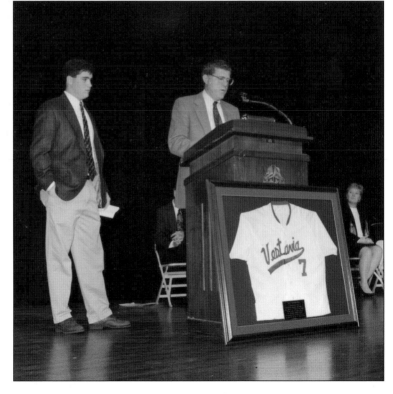

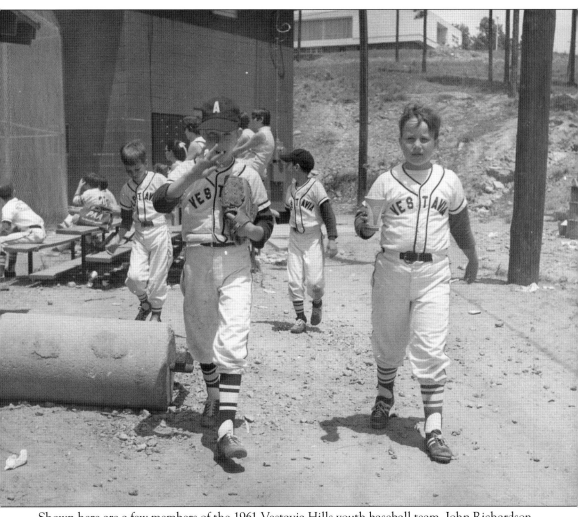

Shown here are a few members of the 1961 Vestavia Hills youth baseball team. John Richardson is at front right, with Joe Black in the center background facing away from the camera. (Courtesy of Sondra Richardson.)

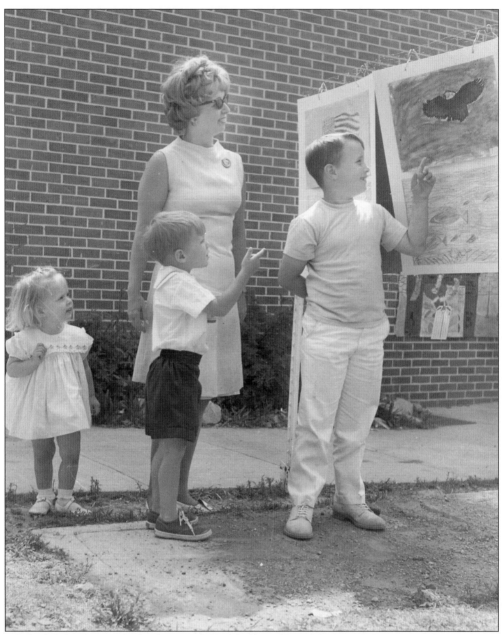

Sondra Richardson is shown here with her children (from left to right) Reiva, Rich, and John. They are admiring John's entries in the 1969 Vestavia Hills School annual art show. At the time, this was still the only school serving the city of Vestavia Hills. Richardson's father-in-law, T.C. Richardson, is credited with helping create the road that runs past the school today. When his two younger children were attending school there, T.C., who owned a trucking company and had access to the appropriate heavy equipment, proposed the idea of a creating a pass-through road to Charles Byrd. At the time, parents had to make a U-turn after dropping off or picking up their children each day. Byrd agreed and donated the land for Richardson to develop. This is in part why the playground that stands just on the other side of that road today is known as Byrd Park. (Courtesy of Sondra Richardson.)

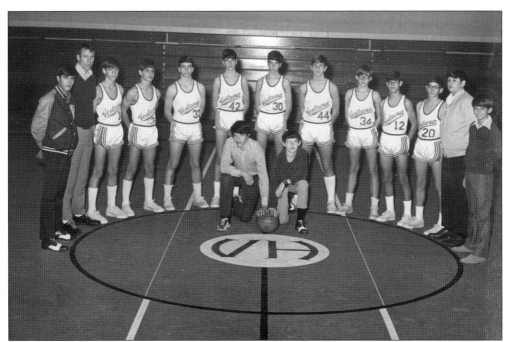

Shown here is the 1970–1971 Vestavia Hills Junior High basketball team. The team was coached by Cooper Ray. (Courtesy of Diane Ray.)

Shown here are VHHS principal Michael Gross with the Vestavia Hills Rebels team doctor, Mike Chandler, during one of the annual traveling flu clinics Chandler's office provided. Each fall, Dr. Chandler would shut down his office for the entire day, load up his bus with office staff, and visit the school, where he would give flu shots to Board of Education employees, school teachers, and staff members at no charge. The bus usually visited the high school around lunch, when the school would provide to-go lunches in appreciation for Chandler's service. (Courtesy of Michael Gross.)

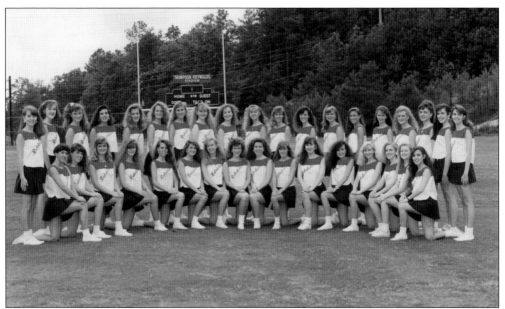

Shown here are the 1993–1994 Rebelettes, the dance team of Vestavia Hills High School. (Courtesy of Cindy Chancey Tyus.)

In spring of 2013, Barbara Spradling hosted her 80th birthday party in the gardens of Sybil Temple. Guests were treated to a three salad lunch and birthday cake for dessert, all served with antique teapots and brightly-colored linens. The occasion was a poignant one for Spradling, who 38 years before, along with other members of the Vestavia Hills Garden Club, helped relocate Sybil Temple to its current location. The effort took two years. By 1975 and with help from both the Garden Club and Harbert Construction Company, the temple was successfully relocated. Since that time, the Garden Club has worked in close cooperation with The Sibyl Temple Foundation—to date 55 members strong—to keep this gateway into the city an attractive, welcoming focal point. (Courtesy of Patricia Barr.)